Barron's Art Handbooks

PASTEL

Barron's Art Handbooks

PASTEL

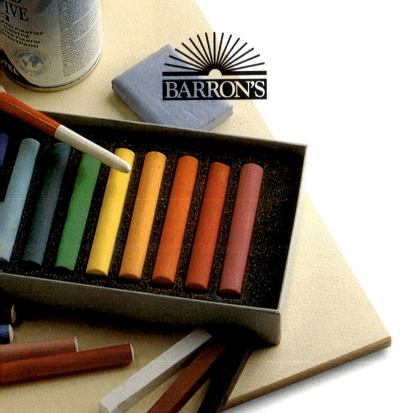

BARRON'S

4

CONTENTS

CONTENTS

5

A BRIEF HISTORY OF PASTEL

Pastel painting as we know it today—that is, as one of the major media of artistic expression through color—is a relatively recent occurrence. From its very beginnings, pastel was closely related to drawing. But it was not until the eve of the Renaissance that drawing came to be viewed as an independent medium. Although pastel was known at the time, it was used only to add a touch of color to drawings that were basically done in charcoal, pen and ink, and so on. Thus, pastel was merely an adjunct of drawing, which itself remained a mere adjunct of painting until the end of the fourteenth century.

Pastel Used to Enhance Drawings in the Fifteenth Century

In the fifteenth century, drawing acquired the status of an independent art form. Ceninno Ceninni, in his book *Il libro dell'Arte*, describes the techniques involved in artistic drawing. Ceninni discusses the materials, tools, and procedures that the artists of the fifteenth century would later utilize.

Andrea de Verrocchio, Paolo Ucello, Piero Della Francesca, Hans Memling, and Jean Fouquet, among many others, discovered the secrets of anatomy and foreshortening.

Drawings were done on colored paper in charcoal, Conté crayon, or scratched into metal to produce engravings. Finishing touches in chalk served to add volume and highlights.

Bernardino Luini (1481–1532). Woman Holding a Fan.

The "Dry Colors Method" of the Renaissance

Toward the end of the fifteenth century, Leonardo da Vinci, genius of the Renaissance, wrote about a French technique called "the dry colors method." Some of the first drawings in which pastel appears are Leonardo's *Portrait of Isabel de Este* and Luini's *Woman Holding a Fan*, both of which were conceived as preliminary studies for paintings.

It was Leonardo who introduced pastel as a highlighting technique for drawings and studies. Other artists would continue its use throughout the sixteenth century.

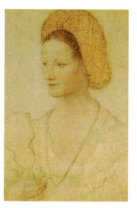

Pastel in the Sixteenth Century

During the sixteenth century, both Michelangelo Buonarroti and Raphael prepared innumerable studies for sculptures and paintings. These were true works of art, not only because of the knowledge of anatomy and perspective that they demonstrate, but also for their extraordinary capacity to express emotion.

Federico Barocci (1526–1612). Study for the Head of an Old Man.

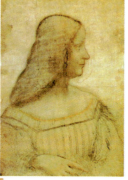

Attributed to Leonardo da Vinci (1452–1519). Portrait of Isabel de Este.

Study of Venus. *Florentine studio, fifteenth century. White is used to highlight the volume of the body.*

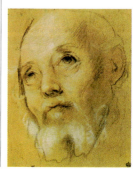

Through the work of the great Renaissance artists and their disciples, drawing took hold as the optimal technique for studies and sketches. These artists—most of whom worked in charcoal, Conté, and white chalk—frequently took advantage of the color of the paper as well.

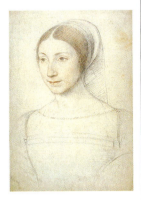

Jean Clouet (1485/90–1541).
Portrait of an Unknown Lady.

As the Renaissance spread throughout Europe, drawing was universally recognized as a fundamental part of the visual arts. Hans Holbein the Younger (1497–1543), a painter from Flanders, was admired for his portraits. Before painting in oil, he would make preliminary studies on hand-dyed paper. Holbein then added chalk and pastel highlights with which he created very delicate colors.

Federico Barocci (1526–1612) always used pastel in his preliminary studies. He successfully continued the legacy of Leonardo, Michelangelo, Raphael, and Titian. Barocci used a pastier type of pastel in place of the more traditional chalk.

Pierre Briard (1559–1609), following in the French tradition established by Jean Clouet, created portraits almost entirely in pastel.

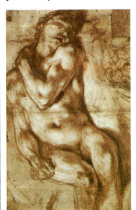

Agostino Carracci (1557–1602).
Dead Man Stretched on the Ground. *This study was done in Conté and white chalk.*

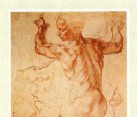

Sheet of studies for the Libyan Sibyl *by Michelangelo Buonarrotti (1475–1564).*
All of Michelangelo's drawings show his exceptional talent for depicting human anatomy. In these studies, movement, gesture, foreshortening, and every aspect of the human body are depicted to the point of perfection.

Drawing, Line, and Movement

One of the most outstanding elements in the development of art during the Renaissance was the knowledge acquired in the depiction of volume and movement. The decisiveness of Michelangelo's line shows a profound knowledge of foreshortening. This technique involves using line to maintain the correct proportions of an object or body in a challenging perspective. The effect of volume is completed by applying color to highlight the shapes defined by the receding lines.

When drawing an arm, for example, foreshortening is defined by the receding lines—those that make the part of the limb that is visually closer to the viewer seem bigger than the parts that are farther away. The receding lines give the impression that the arm is penetrating into the background.

The Baroque and *the Dessin à trois crayons*

Caravaggio learned from Agostino Carracci; Rembrandt, Rubens, de La Tour, Velázquez, among others, learned from him.

Peter Paul Rubens (1577-1640) had more commissions than he could complete. He established a studio where several excellent painters carried out his works according to his studies and preliminary sketches. Rubens

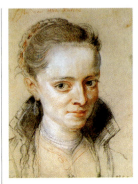

Rubens (1577–1640). Portrait of Susana Fourment. *This work was done in three colors—black, sanguine, and white on colored paper. Note the great mastery in portraying expression and volume.*

developed a style of drawing now called *dessin à trois crayons*. The three colors normally used were black, sanguine (a brownish-red, particularly associated with Conté crayon), and white, usually on cream-colored paper.

MORE INFORMATION
• The Rise of Pastel as a Medium **p. 8**

THE RISE OF PASTEL AS A MEDIUM

Pastel did not become important to the history of art until the eighteenth century, when it emerged as a major force in portraiture. However, the foundation for pastel's appearance as an independent medium had been laid during the previous century.

The Rococo: Pastel Is Born

There were four artists who pioneered the development of pastel painting in the second half of the seventeenth century: Daniel Dumonstier, Charles Le Brun, Joseph Vivien, and Rosalba Carriera. Of these, the latter three in particular used pastel as a painting medium. Their works are a far cry from the pastel-

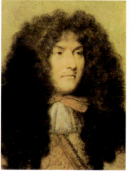

Charles Le Brun (1619–1690).
Portrait of Louis XIV.
This portrait is a typical example of the pastels of this period.

Rosalba Carriera (1675–1757).
Adolescent Girl of the Leblond
Family. *This great painter worked exclusively in pastel, creating portraits of extreme sensibility with an elegant use of light colors and diaphanous effects.*

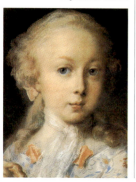

enhanced drawings of their precursors.

In France, the use of pastel as a pictorial medium was closely linked with the court and a variety of themes deriving from this milieu. During the course of the century, the portrait was to be the most widely used genre.

Rosalba Carriera (1675–1757) is the first identifiable female painter in history. Her early work had a diaphanous air, with clean, pure elements. In her more mature work, she demonstrated a profound knowledge of human expression.

A reproduction of one of her more significant paintings appears on this page.

Pastel Applied in Layers as in Oil Painting

Like Carriera, Maurice Quentin de La Tour (1704–1788) and Jean Baptiste Perronneau (1715–1783), continued to work in pastel as a painting medium for portraiture. They presented a more realistic and, at the same time, more austere view in their works.

In addition to his fine portraits, Jean Baptiste Siméon Chardin (1699–1779) is known for his still lifes and scenes of everyday life. His method anticipated Impressionism. He used short, juxtaposed, and highly visible strokes, which caused a strong vibrant effect. Chardin was also the first to use layers of pastel as if painting in oil. He managed to create form through short, thick strokes or dabs of color.

Also worth mentioning as one of the pioneers of this advance towards modernity is Jean Étienne Liotard (1702–1789). He had a highly developed sensibility for softly harmonic colors, as well as an interest in daring compositions.

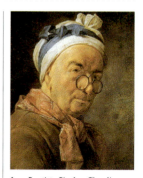

Jean Baptiste Siméon Chardin (1699–1779). Self-portrait.

Romanticism and Its Precursors

At the end of the eighteenth century, works in pastel provided a bridge to Romanticism. The British tended towards the purely romantic in their works, whereas the French took inspiration from the classics. Romanticism and Neoclassicism were the two key movements that heralded Impressionism.

Romanticism's pastel drawing-*cum*-painting (see the work directly below) incorporated the themes of landscape and picturesque genre scenes of everyday life. The Romantic artists Eugène Boudin (1824–1898) and Jean François Millet (1814–1875) both introduced clearly Impressionist elements into their later works through their choice of subject as well as by their technique.

Jean François Millet (1814–1875).
Afternoon Nap. *An example of a drawing-cum-painting with a new genre theme as its subject.*

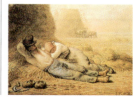

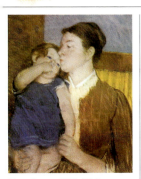

Mary Cassatt (1845–1926). This painting of a mother and child is typical of her work.

Impressionism: New Subjects and Techniques

With the advent of Impressionism, pastel stopped being reserved exclusively for portraiture. In addition, a new pastel method had appeared: defining contours through lines and then applying pure, juxtaposed colors that were blended by the eye of the viewer. Subjects now included landscapes and nudes.

A true pastel artist, Mary Cassatt excelled as well in various other pictorial media. In many of her works she concentrated on scenes of children, often in the presence of their mothers.

Édouard Manet (1832–1883) painted many works in pastel, some of which were portraits that would later be included in large-format oil paintings of genre

Édouard Manet (1832–1883). Manet painted this pastel portrait as a preliminary study for his Bar Near the Folies Bergère.

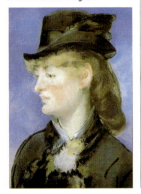

scenes. His pastel paintings are remarkable for their freshness and loose style.

All of the Impressionists created works in pastel. The freshness and immediacy of the results made this medium ideal for artists who were attempting to capture the fleeting, momentary impact of light and movement. Some of these artists were Monet, Degas, Berthe Morisot, Mary Cassatt, Pissarro, Renoir, and Whistler.

Edgar Degas (1834–1917). Twirling Ballerinas.

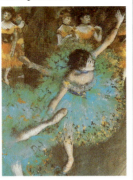

Edgar Degas

Degas studied movement, color, and light in unusual compositions that focused on three major themes: women bathing, dressing, or doing their hair; ballerinas; and horses. The pastel medium provided a great range of effects for depicting these subjects. Degas investigated and mixed powdered pigment with gum and other materials, managing to produce thick impastos of incredible opacity that multiplied the pictorial possibilities of pastel.

Post-Impressionism: Gauguin, Toulouse-Lautrec, and Odilon Redon

Paul Gauguin felt a strong attraction to the exotic. In his frequent travels to Tahiti, he often used native women as subjects for his paintings.

Henri de Toulouse-Lautrec, a painter and lithographer with an extraordinary talent for drawing, used both pastel and gouache

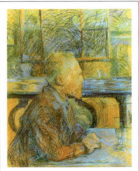

Toulouse-Lautrec (1864–1901). Portrait of Vincent Van Gogh.

with incredible skill in his numerous sketches and studies for posters and paintings.

Odilon Redon exquisitely combined pure colors in his flower arrangements as well as in portraits and symbolist paintings.

The Twentieth Century: Symbolists and Expressionists

Pablo Picasso, the Expressionist Edvard Munch, the Surrealist André Masson, Joaquim Mir in his landscapes, and even Paul Klee in his nonfigurative period used pastel for paintings and studies.

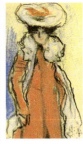

Pablo Picasso (1881–1973). Pastel on paper.

Fauvism: An Explosion of Color

Fauvism was one of the most coloristic movements in the history of art. Many artists belonging to this school worked in pastel producing truly extraordinary bursts of color.

MORE INFORMATION
· A Brief History of Pastel **p. 6**

WHAT IS PASTEL?

The word *pastel* derives from the term paste, a direct reference to the paste used in its manufacture. There are hard and soft pastels, as well as pastel pencils. The same word is used to define the pictorial medium and the works done in pastel.
Today, the word has yet another meaning that is only indirectly related to the medium. We speak of *pastel tones* when a work has been done in bright, fresh colors with soft, delicately harmonized contrasts. Thus, the name of the medium and the work has transcended its original meaning to indicate a type of palette. Today, no one disputes pastel's position as a pictorial medium with extraordinary chromatic possibilities.

The Pastel Medium Has Infinite Possibilities

Any work in pastel with vivid lines and patches done in pure colors appears striking. True bursts of color can be achieved using the extensive array of hues available on the market. These remarkable ranges allow all the color areas of the work to be linked through surprisingly daring or exceedingly soft combinations.

Pastel is an extremely versatile medium because of the extensive color possibilities it provides.

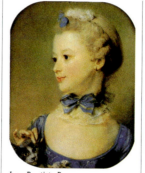

Jean Baptiste Perronneau (1715–1783) executed this portrait with great delicacy.

Chiaroscuro, a Great Pastel Quality

The possibilities and qualities of chiaroscuro offered by pastel are doubtless more spectacular than those provided by any other medium. This is true because pastel offers such a wide range of hues, adding an enormous richness to any depiction of volume. In addition, blending and gradation can eliminate any brusque changes of tone.

Drawing or Painting? The Eternal Question

Pastel allows you to draw lines of varying thickness and use them to create an essentially linear composition. It could thus be considered a drawing technique.

On the other hand, the color masses that can be created with pastel make it an undisputed painting medium in its own right.

On rare occasions, a pastel work can be seen predominantly as a drawing. More often, a pastel

This sketch of a sleeping figure by Raset, was done in grisaille—a painting rendered entirely in grays.

painting is a work in which both drawing and painting coexist and complement each other, with blending and gradation of lines and colored areas.

Santamans. Note the extraordinary richness of hues in this chiaroscuro.

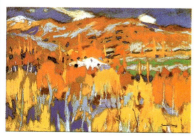

Ramón Sanvicens (1917–1987). Landscape. In this work, the contrast between cold and warm colors lends an extraordinarily vibrant effect.

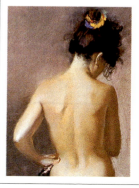

Pigment Tends to Fall off with Time

Carefully examine an antique pastel painting and its frame. If you look at the lower part of the work, you will see pastel powder on the mat and between the glass and the frame. This demonstrates that the powdered pigment eventually comes away from the support, although fortunately, this is a very slow process. Even a well-framed pastel painting will lose many particles of pigment if it falls to the ground or is jostled by accident.

A Canson drawing pad with sheets of laid paper separating the sheets of drawing paper

Pastel Has Many Masters

Sooner or later, all artists attempt to use pastel, be it to draw sketches or to create a major work. Pastel is attractive for many reasons. First of all, it is a direct medium—that is, there is no need for brushes, palettes, or thinners. Although the medium has its difficulties, the wide chromatic possibilities more than compensate. A work done in pastel by an experienced artist rapidly acquires color, depth, and contrast.

Domingo Álvarez. A delicate pastel painting that demonstrates the pictorial character of the pastel medium.

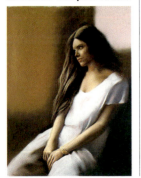

An intermediate solution to the problem of conservation: a passe-partout frame composed of a mat with a rigid protective back and a sheet of acetate for the front.

Serious Problems of Pastel

The pastel medium finds its worst enemy in light. A pastel work will fade quickly, losing its marvelous color properties if exposed to light for too long.

Water and humidity can also cause great deterioration.

Many of the great museums of the world keep important pastel

paintings in specially designed rooms that maintain the optimal degree of humidity and light to ensure their longevity. An example would be the Musée d'Orsay in Paris.

Methods of Conservation

A work done in pastel is very fragile. An inadvertent scrape of the hand or the sleeve across its surface will inevitably leave a smudge. This often proves fatal to the work. Although the artist may attempt to repair the damage, the original freshness of colors is never regained.

For a pastel artist, the best solution to the problem of conservation is to protect the painting by framing it under glass. This, in combination with avoiding exposure to direct light, should be enough to preserve the work.

A strictly temporary measure is to cover the painting with a sheet of special (laid) paper. The use of a *passe-partout* frame (see illustration above) would provide an intermediate solution.

Another possibility is to try a spray, although the use of aerosols as fixing agents is a highly controversial issue.

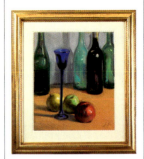

The best way to preserve a pastel painting is to frame it correctly.

MORE INFORMATION

· Pastel, an Intimate Medium **p. 20**
· Special Attributes of Pastel **p. 40**
· Pastel as a Drawing Medium **p. 42**

DIFFERENT TYPES OF PASTEL

A wide variety of pastels is available in fine arts stores: soft and hard pastels
that come in various sizes and shapes (including square-edged and cylindrical sticks),
pastel pencils, oil pastels, wax crayons, and so on. They can be classified by
composition and by specific use.

Composition

By definition, pastel is a conglomerate created by mixing powdered pigments (the coloring agent), gum arabic or tragacanth (the agglutinating agent), chalk (for lighter colors), and the necessary amount of water. Different types of pastels can be obtained by modifying the proportions of the ingredients.

Pastels Are Generally Very Fragile

Applying too much pressure on a stick of chalk or pastel will cause it to break. Pastel pencils, consisting of a pastel core enveloped by wood, are less fragile as long as they are not dropped to the floor. The soft, molded base on which soft pastels are packed provides protection against breakage in case the box accidentally falls to the floor. The molded liner also keeps the sticks separate and therefore cleaner.

The fragile nature of soft pastels.

A stick of soft pastel is composed of pure pigment, gum arabic as an agglutinating agent, and some chalk to lighten the color.

The Degree of Hardness

Gum arabic and gum tragacanth are the only agglutinating agents that can give the powdered pigments enough rigidity to form a stick shape. Pastels with more gum in their composition will be harder and more durable; those with less will be more fragile.

Pastels can be categorized by their degree of hardness—a characteristic that is important when considering the possible uses of different pastels.

Characteristics of Soft Pastels

Soft pastels contain little agglutinating agent and therefore easily crumble or break when used. Since they are mostly pigment, the color they produce on paper is very intense. This type of pastel usually comes in cylindrical form.

Uses of Regular and Extra-Large Soft Pastels

Soft pastels provide vivid colors and adhere best to the surface of the support (usually paper). This is why it is the soft pastels that come in the widest possible range of colors. They are used to achieve essentially painterly effects.

Soft pastels. Note their cylindrical shape and the protective paper strip.

Extra-large sticks of soft pastel are also available. These allow large surfaces to be covered more quickly.

Compare the difference in size. The large stick of soft pastel allows larger surfaces to be colored quickly.

Hard Pastels

Hard pastels are easily recognizable by their rectangular stick format. They are generally more compact and thinner than soft pastels. Hard pastels also contain more agglutinating agent and are heated to increase their hardness. When pressure is applied to a stick of hard pastel, it is less likely to break than a soft one.

MORE INFORMATION

· Manufactured Products Available **p. 14**
· Color Charts **p. 16**

The edges of hard pastels can be used to draw fine lines.

Use of Hard Pastels and Chalk

Hard pastels can be used for drawing. Their hardness allows the stick to be sharpened sufficiently to achieve extremely fine lines. In addition, if held lengthwise, they can be used to color in wide areas just as with soft pastels. The greatest difference between the two is that hard pastels do not provide colors as intense as do soft pastels. For these reasons, they are used less to paint than to draw.

Though soft pastels come in extensive color ranges, hard ones are only available in more limited assortments. This is because they are considered an adjunct of soft pastels. Soft pastels adhere better to the paper, thereby giving the work greater longevity.

Chalk is a type of hard pastel. It is often used to sketch the preliminary outlines of a composition.

Chalk is a type of hard pastel that is available only in very limited color assortments. Because of their high chalk content, they are the easiest type of pastel to blend. They also come away from the paper very easily. For this reason, many pastel artists use chalk to sketch the preliminary outlines of a composition.

Pastel Pencils

Pastel pencils, which are somewhat thicker than normal lead pencils, have a core of very hard pastel. This is the pastel with the greatest amount of agglutin-

The core of these pencils consists of a thin stick of hard pastel.

ating agent and is therefore unlikely to break in the normal course of drawing. These pencils can be sharpened sufficiently to obtain very fine lines.

One of the most elementary precautions to take with pastel pencils, as with any other type of pencil, is to avoid dropping them. Broken leads are exasperating and greatly decrease the pencil's longevity.

Pastel pencils are used for small format works, sketching, and outlining.

Are All Pastels Compatible?

All professional pastel artists combine the use of soft and hard pastels and pastel pencils. The artist can draw in the general lines of the composition in chalk, continue with soft pastels to achieve painterly effects, and alternate these with hard pastels for drawing lines or shading. Finishing touches and details can be done in pencil.

Watercolor Pastels

Although all pastels except oil pastels and wax crayons can be blended with water, there are some pastels that are made specifically for use with a paintbrush and water.

Oil Pastels

Oil pastels come in the classic cylindrical stick shape, but oil is added to the paste instead of gum as an agglutinating agent. Along with the color, turpentine is applied onto the paper as a thinner. Although the appearance may resemble the results achieved with soft pastels, the technique is different.

Wax Crayons

Wax crayons also come in cylindrical sticks. They differ from pastels in that they contain wax as an agglutinating agent. Like oil pastels, crayons can be thinned with turpentine, producing very special effects.

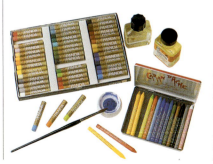

Oil pastels and wax crayons can be thinned with turpentine. They are available in sticks or as pencils.

MANUFACTURED PRODUCTS AVAILABLE

Pastels, especially soft pastels and pencils, offer one of the most extensive arrays of colors available in any fine arts medium. For hard pastels, especially chalk, the range of colors is more limited; and the same is true of extra large soft pastels.

• •

A Wide Variety of Colors

Soft pastels come in wide and varied assortments. The largest selection of colors is offered by Sennelier in a collection of 525 soft pastels. Most of the recommended brands offer various boxed sets. Any of these boxes contains a variety of colors, including various tones of the same color. In most cases, the selection is sufficient to handle any possible problems of color for any subject. These are standard assortments.

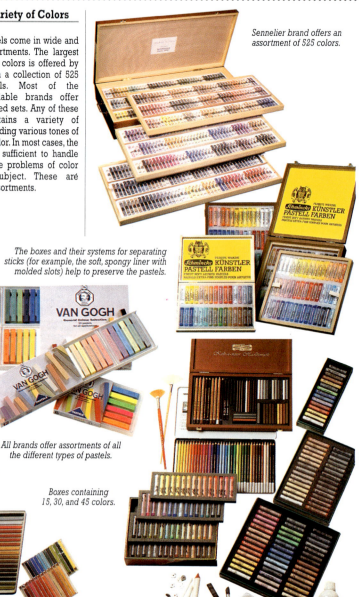

Sennelier brand offers an assortment of 525 colors.

The boxes and their systems for separating sticks (for example, the soft, spongy liner with molded slots) help to preserve the pastels.

All brands offer assortments of all the different types of pastels.

Boxes containing 15, 30, and 45 colors.

Special Assortments for Specific Themes

In addition to the standard color assortments, there are also special assortments available. These provide color ranges that are usually only used to paint specific themes. The landscape assortment, for example, contains many variations of ochres, earth tones, blues, and greens. A seascape assortment offers many different shades of gray, green, and blue. For figures and portraits, there are assortments specializing in flesh colors. Assortments for painting flowers contain many vivid colors so that the flowers can be portrayed with striking intensity.

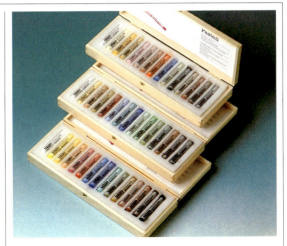

Special color assortments for specific themes, such as landscapes, seascapes, and portraits.

Hard pastels come in somewhat limited selections. Arrangements in special assortments of various colors—warm colors, cool colors, and different shades of one particular color—make it easier to find any particular hue.

MORE INFORMATION

· Color Charts **p. 16**

The Presentation of Colors in Specific Assortments

All of the important brand names present their pastels in cardboard or wooden boxes. Both large assortments and special assortments (for landscapes, seascapes, flowers, and so on), are arranged by color. Assortments of different hues of one color are also available. A box of grays, for example, offers various shades of gray. The great advantage of arrangement according to colors is that it permits comparison of neighboring hues—thereby facilitating choice of the precise color needed for a particular application.

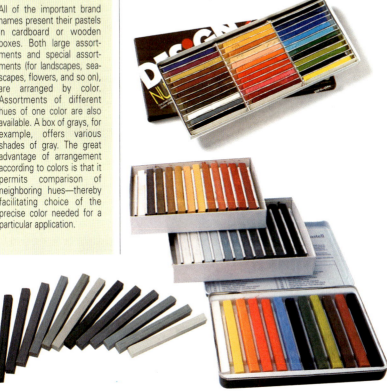

COLOR CHARTS

Most quality brands offer extensive assortments of soft pastels. Differences of
hue or tone can be very subtle when dealing with such wide ranges.
Color charts (furnished by each manufacturer and including data on
pigments and lightfastness) allow easy location of specific colors
because they present similar colors in juxtaposition.

Schmincke Color Chart (280 colors)

+ Deep ⟵ — Full —————————————⟶ + Light

B ⟵————●————D ⟹————⟹ H ⟹————⟹ M ⟹————⟹ O

No.	Name / Pigment	Lightfastness
002	Permanent yellow 1 lemon — Permanent azodye pigment	***
003	Permanent yellow 2 light — Permanent azodye pigment	***
004	Permanent yellow 3 deep — Permanent azodye pigment	***
005	Permanent orange 1 — Permanent azodye pigment	***
013	Light ochre — Iron oxide	*****
014	Gold ochre — Iron oxide	*****
016	Flesh ochre — Iron oxide	*****
017	Orange ochre — Iron oxide	*****
018	Burnt sienna — Iron oxide	*****
019	Light burnt ochre — Iron oxide	*****
021	Pozzuoli earth — Iron oxide	*****
022	Light oxide red — Iron oxide	*****
023	Light caput mortuum red — Iron oxide	*****
024	Deep caput mortuum red — Iron oxide	*****
028	Light olive ochre — Iron oxide + chromium oxide	*****
029	Deep olive ochre — Iron oxide + chromium oxide	*****
030	Umber green — Iron oxide	*****
032	Dark ochre — Iron oxide	*****
033	Burnt sienna green — Iron oxide	*****
035	Burnt umber — Iron oxide	*****
036	Vandyke brown — Iron oxide	*****
037	Sepia brown — Iron oxide	*****
042	Permanent red 1 light — Permanent azodye pigment	***
044	Permanent red 3 deep — Permanent azodye pigment	***
045	Madder red — Permanent azodye pigment	***
046	Carmine red — Permanent azodye pigment	***
047	Madder pink — Permanent azodye pigment	***
099	Black — Carbon black	*****

001 White ***** — Titanium dioxide

*This color chart should be read horizontally for each color, from
deepest (B) to lightest (0), with three intermediate tones: (D), (H), and (M).*

Schmincke Color Chart (continued)

Key:
***** Maximum lightfastness **** Very good lightfastness
*** Good lightfastness ** Satisfactory lightfastness
* Sufficient lightfastness

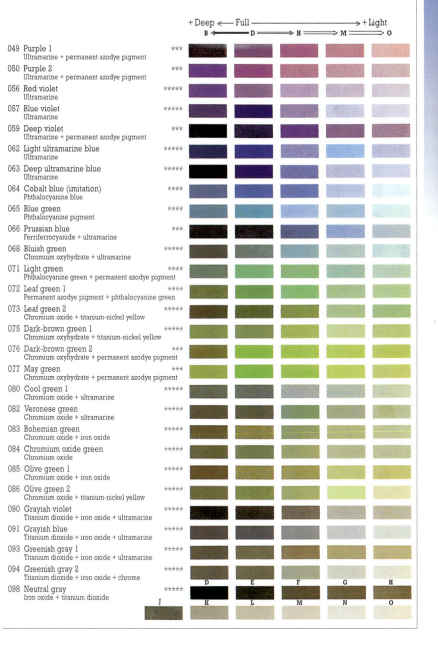

+ Deep ⟵ — Full — ⟶ + Light
B ⟵ D ⟹ H ⟹ M ⟹ 0

049 Purple 1 ***
Ultramarine + permanent azodye pigment

050 Purple 2 ***
Ultramarine + permanent azodye pigment

056 Red violet *****
Ultramarine

057 Blue violet *****
Ultramarine

059 Deep violet ***
Ultramarine + permanent azodye pigment

062 Light ultramarine blue *****
Ultramarine

063 Deep ultramarine blue *****
Ultramarine

064 Cobalt blue (imitation) ****
Phthalocyanine blue

065 Blue green ****
Phthalocyanine pigment

066 Prussian blue ***
Ferriferrocyanide + ultramarine

068 Bluish green *****
Chromium oxyhydrate + ultramarine

071 Light green ****
Phthalocyanine green + permanent azodye pigment

072 Leaf green 1 ****
Permanent azodye pigment + phthalocyanine green

073 Leaf green 2 *****
Chromium oxide + titanium-nickel yellow

075 Dark-brown green 1 *****
Chromium oxyhydrate + titanium-nickel yellow

076 Dark-brown green 2 ***
Chromium oxyhydrate + permanent azodye pigment

077 May green ***
Chromium oxyhydrate + permanent azodye pigment

080 Cool green 1 *****
Chromium oxide + ultramarine

082 Veronese green *****
Chromium oxide + ultramarine

083 Bohemian green *****
Chromium oxide + iron oxide

084 Chromium oxide green *****
Chromium oxide

085 Olive green 1 *****
Chromium oxide + iron oxide

086 Olive green 2 *****
Chromium oxide + titanium-nickel yellow

090 Grayish violet *****
Titanium dioxide + iron oxide + ultramarine

091 Grayish blue *****
Titanium dioxide + iron oxide + ultramarine

093 Greenish gray 1 *****
Titanium dioxide + iron oxide + ultramarine

094 Greenish gray 2 *****
Titanium dioxide + iron oxide + chrome

098 Neutral gray *****
Iron oxide + titanium dioxide

WHY SO MANY COLORS?

Upon entering a well-stocked fine arts store and noticing how many brands of pastels are available and how wide a selection of colors is offered, you may find yourself wondering: Why so many colors?

Dry Medium and Color Mixtures

The dry medium of which pastel is made lends itself to mixture. There are several procedures for mixing colors in pastel: those that are done directly on the support, and those that are done in a separate container. The latter method is generally used to produce color for covering a large surface, or to develop a very special color. Mixing pigments separately is neither practical nor quick, and it breaks the natural spontaneity and immediacy of normal pastel painting.

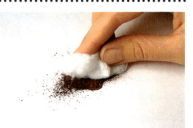

Here is an example of mixing carmine and sienna in powder form. Some absorbent cotton is used to spread the color over the paper.

It is best to apply pastels so as not to use the entire capacity of the paper to hold pigment. For example, a fan brush or a piece of cotton ball can help to spread pigment without applying too much pressure. These imple-ments may even carry some pigment away with them. A saturated surface looks dirty. This is one of the greatest dangers of mixing colors on the support. The result is frequently a muddy painting.

Adhesion of Pigment to Paper

The adhesion of pastel pigment to paper has a certain limit, called the saturation point. Applying pressure with the fingers on pigments already applied to the paper in order to mix them will embed the particles in the surface, filling in the natural cavities of the paper's grain. When the support paper becomes saturated, color can no longer be added. One trick of the trade is to use a fixative to increase adhesion to the paper, but the usefulness of this solution is debatable.

Mixing Colors Separately

There is nothing better than a simple example to explain a problem. Let's suppose we have four sticks of pastel: yellow, blue, white, and green. We can attempt to get the same shade of green as the green pastel by mixing the yellow and blue pastels, then adding white as necessary. If we try this, we will see just how difficult it really is to make even such a simple mix successfully. It is actually very difficult to produce a similar color. When applied to paper, the color we mixed will look dirty in comparison to the original manu-factured green pastel. Upon examining the paper closely after carrying out the mix, we will also notice that all of the cavities in the grain of the paper have been filled. It is easy to saturate the paper when mixing colors.

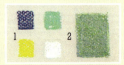

1) Sample patches of the four manufactured colors. 2) Blue mixed with yellow and white. Compare this color to the one produced with the manufactured green pastel.

Example of a mixing process: 1) Apply yellow to blue. 2) Mix both colors, blending them with your fingers directly on the paper.

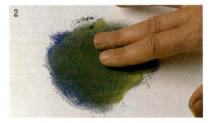

Color Charts
Why So Many Colors?
Pastel, an Intimate Medium

19

Why So Many Colors?

The wide range of available colors lessens the need to mix pastels. With such a wide spectrum of ready-made hues, there is less need to mix than in other pictorial media. In any case, if a mixture is necessary, do it in a way that it does not cause the paper to become saturated.

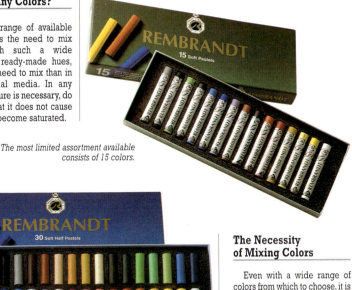

The most limited assortment available consists of 15 colors.

A very practical box of 30 half-length pastels.

The Disconcerted Beginner

You may find the wide range of colors available bewildering. A somewhat limited standard assortment of colors can be a good choice for your initial efforts. This will allow you to acquire practice in mixing and to understand the limitations of the medium. With experience, you can widen your range of colors to suit your own preferences.

Reduced Palette Suggested

A box of 15 colors would be a good choice for a beginner. A box of 30 colors in half-length sticks occupies little space and doubles the choice of color shades. An assortment of 45 colors will permit you to take on more challenging works.

The Necessity of Mixing Colors

Even with a wide range of colors from which to choose, it is sometimes necessary to make a mixture in order to achieve certain hues or effects.

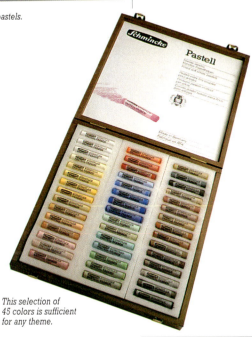

This selection of 45 colors is sufficient for any theme.

MORE INFORMATION

· Manufactured Products Available **p. 14**
· Color Charts **p. 16**

PASTEL, AN INTIMATE MEDIUM

Many pictorial media establish a distance between the artist and the work. Unless
you want to soil yourself, you will have to use a paintbrush or spatula when working in oil.
These tools mean the loss of direct contact with the painting. In contrast, only on rare
occasions does a pastel artist *not* come into direct contact with the work.

How to Hold Pastels

Sticks of soft pastel now often come wrapped in protective paper strips that carry identifying information. It is best to remove this strip to leave the entire surface of the pastel free for coloring. Hold the stick of pastel either like a pencil or by the sides if coloring with the flat surface. Thus, the fingers are in direct contact with the medium.

The Artist's Sensations

The artist's contact with pastels is very special. It is not difficult to begin to differentiate the various types of pastel just by touch. As a first stage of becoming acquainted with the medium, it can be very enriching to experiment with the pastels and analyze the sensations they produce.

A piece of soft pastel will simply come apart if you press on it with your finger. Rub the remaining powder between the tips of your thumb, index, and middle fingers. Do you feel a smooth, slippery sensation? If you repeat this process with a stick of hard pastel or chalk, or the core of a pastel pencil, you should experience different sensations. Soon you will be able to identify the degree of

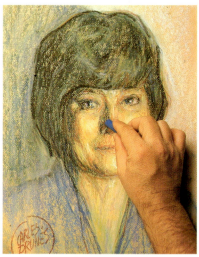

Carles Prunes.
When drawing,
hold the pastel
like a pencil.

Working
directly with
your fingers
allows you to
control the
pressure
applied. The
more pressure,
the more
intense the
color.

hardness of a pastel solely by touch. Without even looking at the pastel stick that you have just picked up, you know whether it is hard or soft.

Removing the protective strip.

A stroke done with the side of the pastel.

MORE INFORMATION
- What Is Pastel? **p. 10**
- Painting with the Fingers **p. 44**

While Painting

To apply color while painting in pastel you must hold the stick in your hand, thus coming into direct contact with the medium. You can feel the pressure exerted with the pastel on the paper or other support. If you then touch the color that you have applied, you will feel the sensation produced by spreading the pigment over the surface. You will notice the degree of pressure being exerted by your finger. Your fingertips can also tell the degree of saturation of the support and even which areas have the least pigment.

Feeling and Intuition

Feelings are difficult to discuss. The capacity to feel varies from individual to individual, but everyone feels something when coming into direct contact with pastels. The free flow of pleasant sensations when working in this

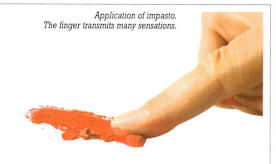

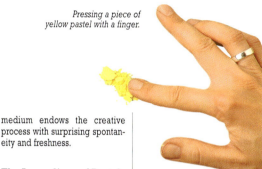

Application of impasto. The finger transmits many sensations.

Pressing a piece of yellow pastel with a finger.

medium endows the creative process with surprising spontaneity and freshness.

The Immediacy of Pastel

Pastel is a dry medium. There is, therefore, no need to wait for the colors to dry once they are applied. Painting and drawing can occur simultaneously. Direct sensations combine with intuitive gestures to allow immediate and spectacular results.

Touching the painting with the hand.

The Intimate Relationship Between Artists and Their Paintings: The Moment of Creation

Imagine the pastel painter, hands covered with bits and pieces of pastel, a dirty rag hanging from the waist, fingers saturated with pigment. The artist's gaze is intense and scrutinizing, eyes intently fixed on the painting. Suddenly, the spell breaks. With an impulsive gesture, the artist jumps into action, adding a touch here, a line there, to round off the composition and eliminate the disturbing imperfection that had caused the previous trance.

SUPPORTS FOR PASTEL PAINTING

A support is the surface upon which pigments are placed to make a painting or drawing. Any surface that does not have a glossy or oily finish can serve as a support for a pastel painting, so long as it has properties that allow pastels to adhere readily.

Colored Paper Specifically Designed for Pastel

There are several brands of paper available for pastel painting. All are the same type of paper as that used for drawing in charcoal, grease pencil, or Conté crayon. Canson produces three well-known types of paper—Mi-Teintes, Ingres, and "C" à grain. Fabiano also uses the Ingres designation. And Rembrandt produces laid paper. These are the most common types. (Note, however, that any particular outlet may offer only some of these brands, as well as others that we have not mentioned.)

Other Types of Paper

A support must fulfill one requirement for pastel painting: to provide ample holding power for the pigment. Therefore, glossy or oily surfaces are inappropriate.

There are many types of paper that, though not specifically produced for pastels, nevertheless permit its adhesion. Paper designed for watercolor painting—textured, absorbent, and porous—usually works quite

Glossy surfaces do not retain pastel.

well. Rough recycled paper, non-glossy packing paper, newsprint, and other varieties provide surprising results when colored with pastels.

Other Possible Supports

A piece of cardboard with a surface that permits the adhesion of pastel pigments can suffice. If it is thick enough, it can even be used without a board for backing.

Another excellent choice for a support can be a wooden panel with a somewhat rough surface.

Primed or unprimed cloth can also make a good support, especially if

it has a rough texture.

Industrial sandpaper is an unusual support that has a great capacity for holding pastel

Colored paper especially designed for pastel.

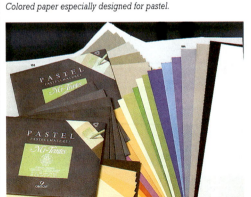

Different textures of various types of paper: watercolor paper, packing paper, handmade paper, and newspaper.

Various supports: unglazed tile, plywood, primed cloth, unprimed canvas, packing cardboard. The strip of color makes the different textures apparent.

pigments. The grain is very hard and rough and easily retains the powder from a stick of pastel, even when it is applied with the slightest pressure.

Sandpaper makes a good support.

Schmincke offers special paper called Sansfix, which is based on the same principle as sandpaper.

Unvarnished pressboard, soaked in a bit of water and allowed to swell, can provide an interesting support after it has dried.

Texture of the Support

Only those supports that provide enough holding power for the color are appropriate for pastel painting. A support with a lot of texture is adequate. Examine the texture of whatever support you may choose to paint on before you proceed. Textured supports can produce singular pictorial effects. It may be worthwhile to consider different possibilities when choosing a support.

MORE INFORMATION

• Colored Paper Specially Designed for Pastel **p. 24**

Treated Supports

You can treat the surface of a support to increase its holding power. Texture can be provided through acrylic or latex primers, to which you can add or agglutinate such elements as sand, wax shavings, or sawdust.

Cloth textured with a layer of latex and whiting.

Adding texture to a sheet of paper by applying latex and sand.

COLORED PAPER
SPECIALLY DESIGNED FOR PASTEL

Although many different types of support are possible for pastel painting, paper designed for this purpose continues to be the most widely used. There are various types of paper available, and the user should become familiar with the peculiarities of each. Two aspects should be analyzed before making a decision: color and the possibilities offered by texture as a pictorial element. Today, there are excellent support papers for pastel that come in a wide variety of formats and colors.

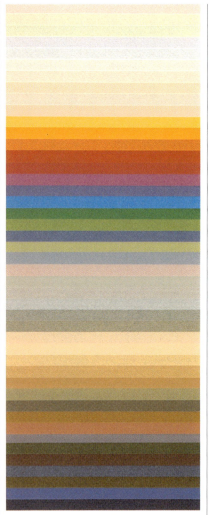

An assortment of Canson Mi-Teintes paper with 48 colors.

Canson Mi-Teintes Paper

Canson's white and colored paper share the same characteristics of strength, texture, and potential longevity. The range of colors for Canson's Mi-Teintes is quite wide, reducing the possibility of saturating the paper. The painter should always choose the color of the paper to harmonize with the general tone of the composition, or to aid in creating a desired contrast. This will lessen the amount of pastel used and thus help to avoid saturating the paper.

Range of Colors for Canson Mi-Teintes

The Mi-Teintes line offers a range of 50 neutral colors. This extensive selection provides an excellent base for most pastel paintings. Mi-Teintes in intense colors allow for good contrasts and can lend great force to a work.

Different Textures on Each Side

Each sheet of Mi-Teintes paper has two different textures, rough grain on one side and fine grain on the other. The level of saturation varies for each side, as do the color effects. One of the first decisions to make is choosing which side of the paper to use.

Different textures and effects:
1. Tests done on the fine side of a sheet of Canson Mi-Teintes: A) coloring in the surface with the flat side of the pastel, and B) the color applied in A after blending with the fingers.

A

B

2. Tests performed on the rough side of a sheet of
Canson Mi-Teintes: C) coloring in the surface with
the flat side of the pastel, and D) blending the
color applied in C with the fingers.

Different Formats

Loose sheets of Mi-Teintes paper come in a large
format measuring 29.5 × 43.3 inches (75 × 110 cm),
and a small one measuring 25.6 × 19.7 inches (65 ×
50 cm). It is also sold in drawing pads of varying
sizes and in packages of assorted colors.

The drawing pads are usually small and have
hard covers that provide a rigid support for drawing
on the paper. However, the latter two options do not
come in as wide an array of colors as loose sheets
bought individually.

Other Brands and Qualities

Canson's Ingres Vidalon paper comes in a more
limited range of colors than Mi-Teintes and is of
lesser quality. The Ingres-Vidalon line does,
however, offer some hues not available in the Mi-
Teintes line. Its texture is also different, and this is
another characteristic that should be kept in mind.

Rembrandt's laid paper also comes in its
particular range of colors; while Schmincke's
Sansfix line offers a unique choice of colors.

All of the mentioned types of papers have
different textures and characteristics that should be
considered.

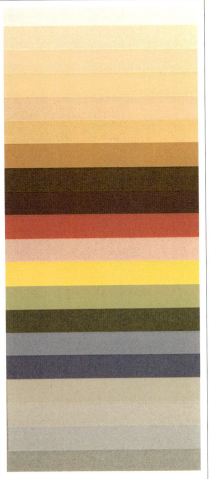

Ingres Vidalon paper, also by Canson,
comes in a more limited range
of colors than the Mi-Teintes.

The Importance of Using
High-Quality Paper

The appearance of humidity stains on a pastel
painting depends as much on the climate as on
the quality of the paper. A work of great
freshness done as a sketch on mediocre paper
can quickly turn yellow, making its conservation
difficult. Although it is difficult to know
beforehand that the work will turn out to be
important, you should use quality paper
whenever you feel inspired—just in case.

MORE INFORMATION

· Supports for Pastel Painting **p. 22**
· The Color of the Paper **p. 46**

BOARDS AND EASELS

Paper, the most commonly used support material for paintings done in the pastel medium, itself needs some sort of support. As in any other drawing technique, a hard backing or board is used. You will also need an easel when working on large-format paintings.

Boards of various materials.

Tacks, clips, or tape can be used to fasten the paper to the board.

Boards in Various Sizes

A backing can consist of any rigid material to which the paper or cardboard for the painting can be attached. The two most important requirements for such a backing are that it remain perfectly rigid even when applying pressure on it to paint, and that it has a reasonable weight. It can be made of any one of a variety of materials—for example, thin plywood or pressboard.

Use of the Board

The paper is usually fastened to the board using clips or thumb tacks. It is also possible to fasten the paper with masking or drafting tape. Make sure the tape is not so adhesive that it will tear the support paper as it is removed.

When painting a work of reduced dimensions, the board need only be slightly inclined. The excess powder from applying the pastel will automatically fall off the paper.

Size of the Board

The board should always be slightly larger than the paper. This permits the paper to be attached to the board, eliminating the need to hold the paper in place with dirty fingers.

Texture of the Board

If the surface of the board is absolutely smooth, the artist can be certain that the only texture to influence the work will be that of the paper. Of course, if the board has a texture of its own, the resulting work will show the combined effects of the textures of paper and board.

These effects can be used to the advantage of the pastelist, who can manipulate them, for example, by using the fine-grained side of the paper to bring out the texture of the board. One point to keep in mind is that the texture could be regular or irregular. In other words, the choice of texture of the board can

open a whole range of possibilities for special effects.

Easels

A large-format work sometimes calls for the use of an easel. To visualize the size and weight of the board required for a large painting, imagine an easel big enough to hold the largest Mi-Teintes paper available, which measures 29.5 × 43.3 inches (75 × 110 cm).

An easel is not only useful for large-formats. It can also serve as an excellent tool to gain perspective on your work. It allows you to place the work in a fixed location and step back to examine your creation from a distance.

There are several types of easels available. A studio easel is the heaviest as well as the strongest. Outdoor easels are usually made of wood, steel, or aluminum. They are light and can be folded for easy transportation. Keep in mind that a very light easel can be blown

Several ways of keeping a small board inclined.

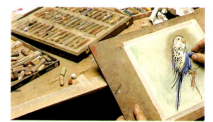

over by a gust of wind. Some folding easels come with a box in which to store pastels and other materials. A tabletop easel takes up little room, but can only be used for smaller paintings.

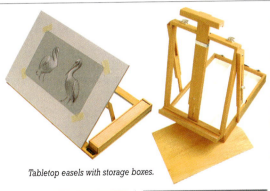

Tabletop easels with storage boxes.

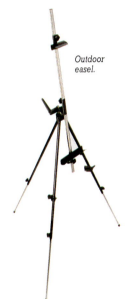

Studio easel.

The Studio

Everyone who feels the need to paint and can spare the time can set up an appropriate space: a studio.

This space is so personal that it is impossible to discuss standard characteristics. Suffice it to say that it is an area in which all the necessary material is at hand and there is sufficient space for painting. An important requirement is good lighting, whether from natural or artificial sources. Pastel painting requires, in addition, different-sized folders for storing finished works. No matter how small it may be, a studio should be a place where the artist can concentrate, detached from the outside world, and feel at home. In other words, it should be a pleasant place in which to paint.

MORE INFORMATION:

• Various Materials **p. 28**

Outdoor easel.

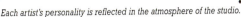

Each artist's personality is reflected in the atmosphere of the studio.

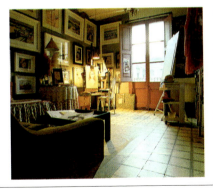

VARIOUS MATERIALS

In addition to the support paper, board, easel, and pastels, an artist may need many other tools. The following list of materials is simply a general guide. The items cited should cover the needs of most of the operations done in pastel. Keep in mind that other materials with similar characteristics can be just as useful as the ones that are mentioned.

Fixatives

There are many fixatives available on the market today. The ones most appropriate for pastel painting are those that are designed for use with charcoal, Conté, or pastel itself. They are highly flammable products and must be handled with care. In addition, they are toxic and should be held at arm's length when spraying. Keep the windows open to create a flow of air or spray the painting outdoors.

Fixatives come in bottles or aerosol cans. When spraying a pastel painting, it is important to apply a thin, homogenous layer to avoid smudging the colors. The aerosol spray is therefore the more commonly used of the two styles, although a bottle fitted with an atomizer also works well for pastels. For more information on how to use bottled fixative, see page 50.

Color can be rubbed off the surface of the paper using an extremely soft eraser that will not damage the painting. The soft inner part of a loaf of bread works just as well.

Maulstick

The maulstick allows you to avoid accidentally touching the surface of the painting when drawing. It can also help you draw a steady line when necessary. Some artists never use this tool; others employ it only for specific operations. To use it, keep the ball end fixed in place just off the edge of the drawing with one hand. Rest the other on the stick to draw steady lines without having to touch the picture.

Stumps

Stumps are made of porous paper, felt, or leather rolled into a pencil shape. They come in various sizes and, as the name indicates, are used for stumping, smudging, or blending.

Suggested Material for Working Outdoors

For a conventional pastel painting, you should take along the following materials: outdoor easel, board, paper, clips, folder, protective paper, aerosol fixative, a clean cotton rag, a cutter, stumps, a fan brush, paintbrushes, several cotton swabs, some absorbent cotton, a kneaded eraser, charcoal pencils, a little chalk (in the most usual colors), a Conté crayon (in sanguine and sepia), and a small assortment of pastel pencils. The pastels themselves will depend on your experience. You can take along a box of 15. With a selection of 30, any subject can be handled. Another suggestion is to take a box of broken pastels. These occupy very little space and function just as well as full sticks.

Additional material: tacks, pliers, cutter, maulstick, kneaded eraser, stumps, cotton rag, fan brush, file, Conté crayons, charcoal, scissors, triangle, paper towels or tissue, and fixative for pastels.

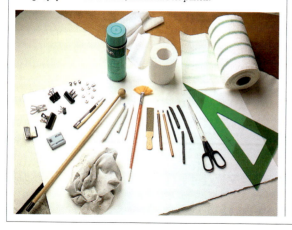

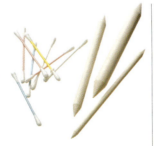

Cotton swabs and absorbent cotton can be used as stumps and for blending tones. Furthermore, they come in handy as painting implements as well as for removing excess pigment from the paper.

Cotton Rag

A soft cotton rag is indispensable for any pastelist. It serves several purposes. It can be used to wipe the hands clean of excess pastel powder, or to wipe pastels that have become soiled after contact with other pastels. But its most important function is to erase color from the surface of the painting. This is why it should be soft.

Absorbent Cotton and Cotton Swabs

Absorbent cotton or cotton swabs can be used to blend. The *sfumato* (or blending of tones) is more delicate than that obtained with a stump because the pressure exerted on the color is very light. Absorbent cotton can cover large areas; cotton swabs are good for touching up.

Paintbrushes

Any paintbrush can be used to blend or to produce effects with water, but the fan brush provides the most delicate results.

File or Sandpaper

A file or sandpaper can sharpen a pastel or grate a stick into powder. Just rub the pastel on one of these instruments. A pencil sharpener will do nicely for sharpening pastel pencils.

Cutter or Scissors

A cutter is an absolute must in any painter's box. It has many uses. It can be used to cut many different types of support—paper, cardboard, or cloth. With it you can sharpen a hard pastel, chalk, or a pastel pencil. You can make *sgraffito* (see page 85), cut a kneaded eraser....

Kneaded Eraser

Because it can hold the most powdered pigment, a kneaded eraser is ideal for working with pastel. In addition, because it is malleable, it can be cut and shaped precisely for each task. It is primarily used to remove color.

Triangle or Ruler

Either a triangle or a ruler can be useful for measuring the size of a sheet of paper. They can also be used for drawing a frame in which to center the painting.

Roll of Paper Towels or Tissues

A roll of paper towels or tissues can be used for any cleaning activity.

Drawing Pencils, Charcoal, and Conté Crayons

Implements for making sketches or for creating the preliminary outlines of a composition are essential. The only thing we recommend is that you avoid using a grease pencil as a base for a pastel painting. The oily lines would reduce the holding capacity of the paper. Watercolor pencils, which produce grease-free lines, are ideally compatible with pastel.

MORE INFORMATION

• Boards and Easels **p. 26**

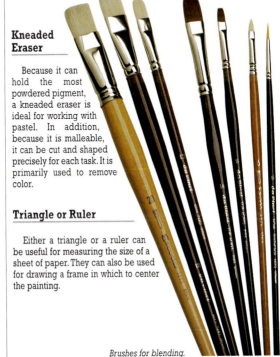

Brushes for blending.

DRAWING AND COLORING WITH PASTEL

A creation in pastel pencil falls essentially in the realm of drawing, but a stick of
pastel can be used in many ways. The various degrees of hardness of pastels
and the difference in pressure exerted on the support paper
all contribute to different coloring effects.

Types of Lines

When drawing or painting a line with the tip of the pastel, hold it like a pencil. Obviously, lines of different thickness can be drawn, depending on the stick of pastel and the pressure exerted on the paper or other support when drawing.

Sometimes very thick lines are desired. In this case, the pastel is held sidewise and color is applied by pushing on the side of the stick.

The thickness of the strokes. 1) The finest lines are executed with the corner of the stick, handled like a pencil. 2) A thicker line is obtained by painting with the bottom of the pastel stick. 3) A very thick track can be used to fill in an area of color by applying the entire side of the stick.

To draw a thick line by painting with the side of the stick, it is advisable to break it in two first.

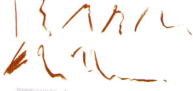

The first line is straight. The other lines are artistic strokes.

To control the thickness of the line, twist your wrist, apply the stick on its flat side, and maintain the same direction of the stroke.

Practical vs. Artistic Lines

When sketching the general outlines of a composition, the lines should be done in hard

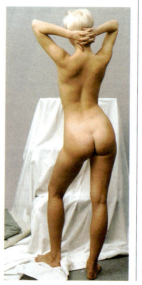

pastel or chalk with very little pressure applied. The purpose of these *practical lines* is to provide guidance for the painting, not to provide artistic results in and of themselves. Therefore, they should mark the surface as little as possible. Later, they can be erased almost completely without affecting the support's capacity to hold pastel powder.

The artist also draws *artistic lines.* The expressive possibilities of this type of line are infinite. The factors influencing the final results of a line are the pressure applied on the pastel when moving across the surface, the changes of direction, and the way

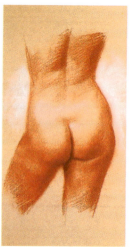

Jordi Segú.
The direction of the stroke is clear.

Color applied without lines.

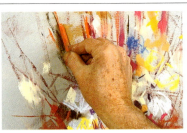

Drawing a line with the edge of a hard pastel.

the stick itself is held. It is said that a pastel painting has good *rhythm* if line and color are applied with the appropriate intention, direction, and intensity. A line can become thinner, fade away, or intensify; and this can occur abruptly or gradually. Artistic lines are ideal for outlining and foreshortening a figure.

The artistic line can make even a sketch a true work of art. The simplicity of the line with which the general composition of a work has been outlined is only apparent. Behind its ability to portray a subject and capture movement lie many hours of practice.

Coloring Without Lines

Painting without lines occurs when color is applied on a support without leaving any visible lines. To achieve this, color is usually applied in circular movements or by brushing the surface with powder. In any case, the important point is to apply the color locally and in a relatively homogenous way. Depending on the pressure exerted, the resulting color will be more or less intense.

Transparent Layers of Color

Lines and general areas of color can be applied with very little pressure. This results in semitransparency. The color of the support remains visible underneath the pigment, and the usual opacity of the applied color is avoided.

Applying Thick Layers

Pastel can be applied in thick layers. The only limiting factor is the capacity of the support to hold pigment, which can be increased with fixatives or mixed media. Thickly applied layers of paint are opaque and completely cover the paper or other support as well as the previous layers of color.

The Fragile Nature of Pastel Sticks; Drawing with Hard Pastels and Chalks

Drawing can be one of the most aggressive activities in pastel painting. Because hard pastels break less easily, even when subjected to the pressure needed to draw, many artists use them for the strongest strokes. Hard pastels are often used for blocking in shapes and outlining compositions, especially at the earlier stages of a painting. Sometimes, though, it is best to use soft pastels because of the extensive color range they offer. If you break a soft pastel stick in half (after the protective strip has been removed), it will become less fragile.

The fragility of pastel.

Joan Sabater. Landscape in chalk. The repeated use of lines done in chalk lend this painting rhythm and personality.

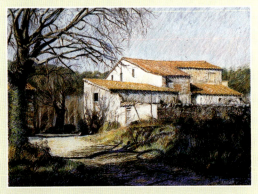

MORE INFORMATION

• Pastel Painting in Practice 2. First Colors **p. 54**
• Pastel Painting in Practice 3. Enhancing **p. 56**

Transparent layer of color. It is softly applied without lines and blended.

COLOR THEORY FOR PIGMENT COLORS

What is color? The reply to this basic question is not at all simple.
In daylight or in total darkness, a blue ball remains a blue ball.
But its blue color can only be perceived by the human eye
when the object is exposed to natural or artificial light.

Basic Tenets of Color Theory

We know from the work of Sir Isaac Newton that the spectrum of white light is composed of the following colors: violet, indigo, blue, green, yellow, orange, and red. Another English physicist, Thomas Young, showed that these colors can be reduced to the three primary colors: red, green, and indigo (blue violet). By isolating each color of the spectrum, Young discovered what is known as *additive synthesis*—that is, in the zone where two colors overlap, they produce a third color. For example, where red and green overlap, yellow appears; where red and indigo meet, they produce magenta; and between green and indigo, blue appears. In additive synthesis, the sum of two colors of the light spectrum produces a lighter color.

Where does an object get its color? In further experiments, Young found that when white light strikes an object, the object absorbs some colors and reflects others. The color it reflects is its own color that the human eye perceives. White objects reflect all the colors of the light spectrum; black objects absorb all colors; gray objects absorb and reflect equal amounts of red, green, and indigo; yellow objects

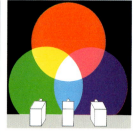

Graphic representation of Young´s experiment.

absorb indigo and reflect red and green; magenta objects absorb green and reflect indigo and red; blue surfaces absorb red and reflect indigo and green. The principle of additive colors for white light derives from this theory.

Our perception of color is the result of the sensations produced in the human eye by different wavelengths of light. The rays are conditioned by the color properties of the object itself and the amount of light hitting it.

Pigment Colors

Pigment colors are not perceived like the colors of white light. Observe the graphics representing *additive synthesis* (corresponding to white light) and *subtractive synthesis* (corresponding to pigment colors). A mixture of pigment colors

Graphic example of how light is absorbed and reflected.

produces darker colors than the original individual colors, as opposed to the lighter colors produced by additive synthesis.

Primary, Secondary, and Tertiary Pigment Colors

Yellow, red, and blue are the primary pigment colors. They are assigned the letter P.

Secondary pigment colors are those resulting from mixing two primaries (P) in equal proportions. Orange is obtained by mixing yellow (P) and red (P); green, by mixing yellow (P) and blue (P); violet, by mixing blue (P) and red (P). The secondary colors are designated with the letter S.

Graphic representation of Newton´s experiment.

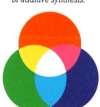

Graphic representation of additive synthesis.

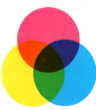

Graphic representation of subtractive synthesis.

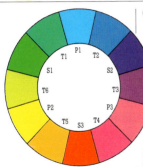

Color wheel of pigment colors, including primary, secondary, and tertiary.

Tertiary pigment colors result from mixing secondary and primary colors in equal proportions. Blue-green is produced with green (S) and blue (P); yellow-green is formed with green (S) and yellow (P); yellow-orange is produced with orange (S) and yellow (P); red-orange is achieved with orange (S) and red (P); blue-violet is made with violet (S) and blue (P); and red-violet is produced with violet (S) and red (P). The tertiary colors are assigned the letter T.

Complementary Pigment Colors

The pigment color blue is complementary to orange; the pigment color yellow's complement is violet; and the pigment color red's complement is green.

According to subtractive synthesis, a mixture of the three primary colors produces black. In a mixture of two complementary colors, some of the three primary colors are present. Therefore, very dark, almost black colors are obtained.

Since a mixture of complementary colors tends to be muddy, be ready to experiment until you achieve clean colors.

If two complementary colors are mixed in clearly unequal proportions, the result is not dark gray. The product is a color tending toward gray, but with the predominant color's hue. This type of mixture, whether lightened with white or not, is known as a neutral color.

Any mixed color can be lightened by adding white. White is necessary when working with pigment colors as a base for lightening other colors.

A watercolor artist working with transparent layers uses the background color of the paper for white areas. Lighter tones can also be achieved with transparency of colors on white paper. An oil painter, on the other hand, must rely on white paint, often in

Complementary pigment colors.

large quantities, because oils are opaque. On pages 34–37, we shall discuss the options available to pastelists.

The Temperature Scale

As discussed, colors can be divided into primary, secondary, tertiary, and neutral. There is also another classification system based on a psychological association of temperature with colors. According to this system, colors are divided into warm and cool categories.

Warm colors produce a warm sensation and give the impression of proximity. Carmines, reds, oranges, yellow-oranges, yellows, ochres, earth tones, red-violets, and yellow-greens fall into this category. Cool colors produce a sensation of coolness and distance. These tones, ranging from green to violet, include blue, blue-green, and blue-violet.

Neutral colors can also be categorized by temperature, according to whether the predominant color of the mixture is warm or cold.

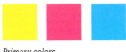

Primary colors.

Secondary colors.

Tertiary colors.

MORE INFORMATION
· Mixtures in Pastel **p. 34**

Most Commonly Used Harmonic Ranges

By definition, a range is any ordered succession of color. Harmony means achieving the optimal relation between all the colors in a painting so as to produce a pleasant visual effect. Most artists consider harmonic ranges when visualizing the color scheme of a painting. The most common harmonic ranges are those of warm colors, cool colors, and neutral colors.

Most commonly used harmonic ranges.

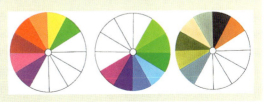

MIXTURES IN PASTEL

The dry medium into which the pigment is incorporated determines all procedures.
Mixtures of pastel colors tend to produce "dirty" colors.
A specific application of the theory of color is derived from
the particular characteristics of pastel.

Mixtures Can Be Indispensable

In the chapter "Why So Many Colors?" (pages 18–19), the difficulty of achieving a specific color by mixing was discussed. Soft pastels come in such a wide range of colors because of their limited capacity to mix, without saturating the paper. Nonetheless, mixing may be indispensable. There is a special method for mixing pastels, obviously conditioned by the characteristics of the medium.

A completely fused mixture appears in the central part of this colored area. It is a good example of a physical mixture.

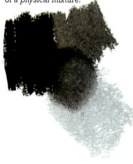

An optical mixture made possible by the rough texture of this watercolor paper.

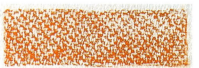

Concept and Types of Mixtures

What does it mean when we say we are making a mixture? There are three possible types of mixtures that the human eye can perceive as a new color.

A physical mixture is one in which both original colors blend completely to form a new one.

In a superimposed mixture, the two colors do not blend. One layer of color is placed on top of another, and the resulting color is that of the lower layer seen through the semi-transparent upper layer.

The third type is the optical mixture, in which there is neither physical nor superimposed mixing. This is achieved by juxtaposing lines or dabs of color on the surface of the painting. The mixing occurs on your retina when you stand far enough away from the painting. It is the optical illusion of a mixture.

Mixtures in Pastel

Despite the limitations of the medium, pastel can be physically mixed. This is done using techniques specific to pastel painting—that is, blending and gradating directly on the support.

Superimposed mixtures can only be accomplished with pastel by spraying the bottom layer of color with fixative and applying the second layer lightly enough to achieve semitransparency. Pastelists who do not use fixatives rarely attempt to mix colors in this way. Without fixatives, the two layers inevitably become physically mixed.

Optical mixtures are the least complicated, once experience is gained in this technique.

The superimposed color, in this case yellow, dominates over the red. The light pressure exerted when applying the yellow allows the red and the support paper's color to come through.

And vice-versa: If red is superimposed on yellow, red will dominate. In superimposed mixtures, the order of application affects the resulting color.

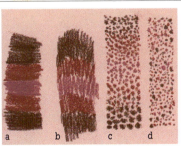

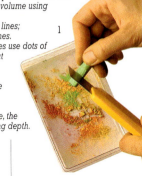

Various examples of optical mixtures that produce the effect of volume using juxtaposed colors:
a) through horizontal lines;
b) through vertical lines.
The next two examples use dots of color (pointillism), but with different intentions:
c) in this example, the intention is to create volume;
d) whereas in this one, the interest lies in creating depth.

Physical Mixtures with Pastels

It has already been mentioned that physical mixtures are carried out directly on the paper or other support (see pages 18–19). Sometimes this type of mixture is necessary. Once the colors have been chosen, a decision must be made regarding the quantity of each color to apply. The amount of color embedded on the paper depends on the pressure applied to the stick of pastel. Only experience and a steady hand can help you achieve the desired results.

Harmonic Ranges

Before beginning a painting, the artist considers the general characteristics desired, including the color of the support and the harmonic range of the work. Depending on the subject, the general tonality may be warm, cool, or neutral.

Whatever the chosen harmonic range, there is such an extensive assortment of colors available that the problems of mixing pastels are considerably simplified. As previously discussed, these problems lie in the adhesion of the pigment to the paper, the nature of the physical mixture, and the saturation of the support.

Value Painting vs. Colorism

Once the harmonic range for a specific subject has been decided, there are two options for working with these ranges: *tonal value* or *colorism* (see page 65).

The tonal option centers on the range of values achieved through blending and gradation. It highlights one of the most important characteristics of pastel—its marvelous chiaroscuro possibilities.

Colorism, on the other hand, is concerned with volume created through contrasting pure colors in optical (as opposed to physical) mixtures. A painting done entirely in this style contains no blending. The colors appear with all the force of pure pigment applied directly from the stick.

Making a Physical Mixture with Little Color

Applying color lightly with absorbent cotton on colored paper provides a good mixture. By shaving powder off two differently colored pastel sticks with a cutter, you can visually estimate how much of each is required to achieve the desired mixture. If the mixture is lightly spread over the paper with a cotton ball, it will cover the surface homogeneously and cause very little saturation of the paper.

1) With the help of a cutter, scrape off the necessary amount of pigment from the chosen sticks.
2) Pick up the color with a bit of cotton.
3) Apply it to a white sheet of paper, spreading it as homogeneously as desired.

MORE INFORMATION
- Color Theory for Pigment Colors **p. 32**
- Blending **p. 36**
- Gradation **p. 38**
- Pastel Painting in Practice 2. First Colors **p. 54**
- Pastel Painting in Practice 3. Enhancing **p. 56**
- Pastel Painting in Practice 4. Blurring and Erasing **p. 58**

BLENDING

One of the most characteristic techniques of pastel painting is blending of colors.
More readily than in any other medium, colors can be blended or
combined directly on the paper.

What Is Blending?

Blending is the intentional blurring of the colors of a line or of a mass so that the contours of the line or the edges of the mass are softened and gradually become almost imperceptible. The definition may seem complex, but the action in itself is very simple when dealing with pastels. Color is applied to the paper in a line or a patch, and then a finger, rag, or stump is wiped over it with very little pressure. The effect is to spread the color, eliminate the clear contours of the line or patch, and allow the colors to become increasingly faint.

Other Blending Techniques

Other techniques used in the pastel medium involve fusing and fading. *Fusing* is to merge two zones so completely that they form one. *Fading* is reducing a color until it completely disappears.

When referring to two colors, fusing means blending the colors repeatedly until the two colors merge together to form a physical mixture. Fading, on the other hand, means extending the mixed color until it gradually disappears.

When blurring contours in pastel, blending, fusing, and dissolving constantly come into play. The Italians call this *sfumato*, a more suggestive term because it combines the concepts of fusing and fading and adds the connotation of dispersion as well. This better describes how blending with pastel makes the color gradually disappear, dispersing it like fluffy wisps of cloud.

Tools for Blending

The most common instrument used by a pastelist for blending is the finger. Fine blending can be done with any finger. Although the tips of the fingers are the most often used, any part of the finger or hand will do as

Color is applied with a stick and is then softly blended.
1) With a finger.
2) With a stump.
3) With a cotton rag.
4) With absorbent cotton.
5) With a fan brush.

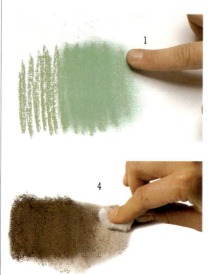

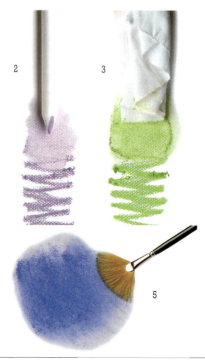

Here it is essential to remove plenty of color. Note how the cotton rag becomes dirty as it picks up the pigment.

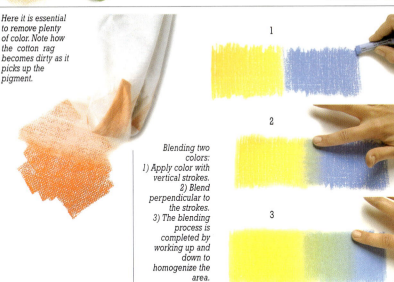

Blending two colors:
1) Apply color with vertical strokes.
2) Blend perpendicular to the strokes.
3) The blending process is completed by working up and down to homogenize the area.

well—the choice depending upon the dimensions of the blending to be carried out. There are other tools, such as stumps, for example. Because they come in the shape of a pencil, they are ideally suited to adding concrete, localized touches. You should familiarize yourself with the use of the stump; learn to control the pressure and investigate the different effects that can be obtained.

Absorbent cotton can be used to spread color homogeneously over a large area. A cotton swab, on the other hand, is useful for touching up. The most important aspect of cotton is that it permits very light blending. Color can be spread over the surface with very little pressure and, therefore, with very little effect on the paper's capacity to hold pigment.

A cotton rag serves to blend and remove some color at the same time. Roll the rag around your finger, usually the index finger, and rub the rag along the precise areas where blending is required. Much of the pigment

will adhere to the rag.

A fan brush or cotton is used whenever blending should be done with very little pressure. The fan shape of the brush, which allows you to control the direction of the blending with great precision, is very useful for creating volume.

Regular paintbrushes of various sizes allow more aggressive local blending and more complete mixtures.

The Use of Blending

Blending is used to attenuate the contours of lines or areas of color. It is also useful for eliminating sharp contrasts between colors or tonalities. It should be employed with great discretion, as repeated blending—particularly the type that calls for stronger friction—will saturate the surface of the support. With practice, you will gain enough experience to blend without having to experiment.

Can Blending and Fusing Be Considered Mixing Procedures?

Blending a single color extends it over the surface of the paper. The color of the support becomes apparent when the pigment thins as it is extended farther from its original area of application. The result is a superimposed mixture.

When two colors are blended, one color is extended over the other. In the area where they overlap, partial fusion occurs. As for blending two juxtaposed colors, where friction is the strongest, a physical mixture takes place.

MORE INFORMATION

• Gradation **p. 38**
• Pastel Painting in Practice. 4. Blurring and Erasing **p. 58**

GRADATION

Gradation is another of the standard procedures used in pastel painting.
The extensive range of colors offered in pastel
allows for truly exquisite results.

Definition of Gradation

Gradation can be carried out in any medium. It is defined as a progression of tones of a color from brightly illuminated to extremely dark. It is used to confer volume (a three-dimensional effect) to a painting on a sheet of paper (a two-dimensional surface). When used in pastel, gradation has several unique characteristics.

Gradating with Pastels

Consider first gradating a single color. Apply the color by pressing more heavily during the first part of the stroke. Then, by gradually letting up on the pressure, you can obtain a gradation that utilizes the background color of the paper.

Painting a subject in a single color will help you to concentrate on gradation. If the paper is light and the color chosen dark, then

Gradations done on several different supports: 1) on the rough side of a sheet of Mi-Teintes; 2) on the finer side of the same type of paper; 3) on a sheet of rough-textured watercolor paper; and 4) on a piece of packing paper.

the dark areas of the composition should be done in pastel; the areas where the most light is depicted should be left clean; and the zones between the two should be filled with gradations of color. In a gradation done with one color, the darkest areas will be the most opaque. As the gradation proceeds towards lighter areas, the layer of color will gradually become more transparent.

On the other hand, if a dark paper is chosen, the pastel should be used to create highlights, with the most opaque layer of color indicating the brightest areas. As the color fades to transparency, it defines the darkest areas of the composition.

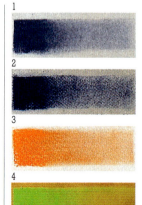

Gradation with Two or More Colors

When working with several colors, gradations are used to soften color contrasts. The results can vary greatly, depending on whether the range of colors chosen is wide or narrow.

Examples of application of colors:
a) two hues of carmine;
b) two more distant hues of carmine;
c) two contrasting colors;
d) an extreme contrast;
e) colors applied in tonal gradation.

In this picture, the colors from the previous example have been blended. The results are as follows:
a) an intermediate tone of carmine is obtained;
b) the contrast between hues is diminished;
c) the resulting mixture diminishes the contrast;
d) the extreme contrast is toned down;
e) volume appears and tonal contrasts are eliminated.

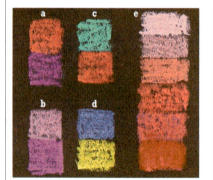

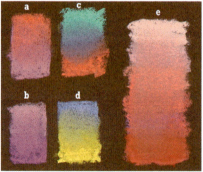

Gradation Exercises

Apply these colors as in the example on the previous page:

a) Apply juxtaposed lines of two carmines that are rather contrasty.

b) Do the same with two tones of carmine.

c) Try two contrasting colors.

d) Now use two extremely contrasting colors—specifically, choose complementary colors in their most intense tones.

e) Attempt to apply color in a progressive tonal gradation.

To obtain an optical mixture of the colors in a), b), c), d), and e) on the previous page, hold the book in both hands and slowly move it away until you begin to see the colors as mixtures and not as individual colors.

MORE INFORMATION

- Blending **p.36**
- Pastel Painting in Practice 4. Blurring and Erasing **p. 58**

Blending a Gradation

Blend the colors in the previous example. The best way to do this is to use your index finger, rubbing it over the paper in one direction. Begin with the lightest color and move on to the darkest if the resulting gradation is to be light, and vice-versa if it is to be darker.

If a single stroke does not eliminate brusque tonal jumps or excessive color contrasts, try blending again. This time rub your finger along the line between the two colors. Proceed from top to bottom. Blending should not be attempted too many times in the same place.

Try gradating the same colors applied in the previous exercise.

a) By blending and fusing you can obtain an intermediate color that reduces contrasts.

b) Again, by blending and fusing you can obtain an intermediate tone of carmine, thus avoiding a tonal contrast.

c) By blending and fusing you can obtain a color mix that softens the contrast.

d) The area between such disparate colors produces different tones.

e) Blend and fuse all of the gradations.

The Direction of Blending

The direction in which blending is done is very important. Because pastel is an opaque medium, different results are obtained when blending two juxtaposed colors, depending on the direction of blending. Blending involves spreading pigment powder onto another color with which it only partially mixes.

The most important rule is that *the direction of blending should follow the representation of volume in the painting, keeping in mind chiaroscuro elements and shading.*

Creating a Gradated Background

Let's suppose we are about to paint a landscape. In order to paint a clear sky, we start with a gradation in blue that will cover a large area of the paper. Because the area is large, the color should be completely blended and spread softly and homogeneously. For this theme, a strip of dark blue is painted near the top and carefully blended with the finger to obtain a homogeneous result. To begin the gradation, a strip of lighter blue is applied just below this area. Then both colors are homogeneously fused until all tonal contrasts disappear. The operation should be repeated with lighter colors each time or with the appropriate color for your composition. The object is to add, blend, and fuse the colors until you obtain the clear sky desired—one without too many clouds, which will not need to be painted over. Another method is to apply all the strips of blue, one after another, and then proceed to fuse them.

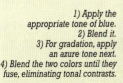

1) Apply the appropriate tone of blue.
2) Blend it.
3) For gradation, apply an azure tone next.
4) Blend the two colors until they fuse, eliminating tonal contrasts.

SPECIAL ATTRIBUTES OF PASTEL

Paintings done in pastel are simply spectacular. Some can consist of magnificent bursts of color, whereas others can have indescribably delicate characteristics with soft, exquisitely blended hues. Let us discuss pastel's attributes and its great possibilities.

What Is Chiaroscuro?

Chiaroscuro is a system of shading in which the tonal gradations of all the elements in a painting are analyzed. For each specific theme, every object represented must be considered according to how much light strikes it. There are many different types of light. Therefore, the specific characteristics of light in a painting—including its source, direction, and strength—must first be established. Observe the effects of light on a subject. There are brightly illuminated areas, some that are in half-light, and some that are quite dark. A gradation should be applied that will unite all these areas harmoniously, gradually moving from the most brightly illuminated to the darkest. A sketch acquires volume with the addition of good chiaroscuro effects.

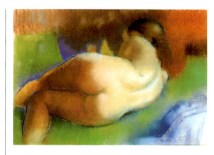

Francesc Crespo. Note the magnificent chiaroscuro work done in this painting. It produces an exceptional impression of volume.

Light and Color in Chiaroscuro

Light is the controlling element of chiaroscuro. Direct light produces contrasts and sharply defined contours. A diffuse light, on the other hand, produces soft shadows lacking definition and contrast. Light affects any object that it strikes. A good way to experiment with light is to use a lamp with a dimmer switch and observe the different types of atmosphere that can be created with different intensities of light. Try sitting in a totally dark room and then turning the light on

ever so slightly. Concentrate on the tonal changes produced on any one object in particular. Continue the experiment by slowly turning up the light. The tones of your object change as the light changes. You can also experiment with the effects of changing the direction of the light. Light will always be reflected from the surface of an object it is striking.

We will begin discussing the chiaroscuro technique by creating chiaroscuro with one color, as in the example on page 38. This simple step can be enriched with the addition of highlights in a lighter color. With a simplified range of tones, only simultaneous contrasts come into play. In other words, the darker the color surrounding it, the lighter a light color will seem. When working with several colors, the law of simultaneous contrasts becomes more complex.

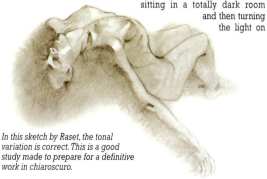

In this sketch by Raset, the tonal variation is correct. This is a good study made to prepare for a definitive work in chiaroscuro.

Ballestar. Volume can be expressed through an extensive range of colors. In this example, the volume is expressed solely through color, without blending.

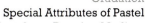

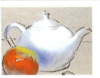 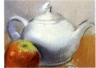 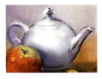

Ballestar. Here is the same teapot done in a different style. The volume in this case is achieved through contrasts between light and dark tones. This is a good example of delicate blending. The extraordinary chiaroscuro provided by the pastel medium can be seen in the various stages.

Simultaneous Contrasts in Chiaroscuro

The law of simultaneous contrasts states that a color seems lighter the darker the surrounding color; conversely, a dark color seems darker the lighter the color around it.

Therefore, a tonal contrast is produced when two different values of the same color are juxtaposed. A color contrast is produced by juxtaposing two different colors. The greatest contrast is achieved by juxtaposing two complementary colors in their most saturated tones.

Contrast and Induction Factors

According to induction of complementary colors, a color will cast its complementary color onto a neighboring color or shade. In practice, any stroke in color will influence the surrounding colors with its complement.

Interrelating Colors Appropriately

The different colors of a composition should be examined to establish the appropriate relations between colors as well as the elements of chiaroscuro needed to create a harmonic whole.

Incorporating chiaroscuro, using simultaneous contrasts of both tone and color, handling complementary colors, and controlling induction factors—all of these tasks require a great capacity for observation as well as much experience.

Pastel Provides an Excellent Chiaroscuro

The chiaroscuro obtained with pastel offers an exceptionally rich representation of volume. With such a wide range of colors to choose from, it is possible to create volume simply by choosing the pastel of the appropriate hue. From this color base, the volume of any element can be portrayed with absolute veracity through blending and gradation.

The Freshness of Pastel

How can freshness be achieved? Through hard work! Only experience can provide the knowledge to choose the right type of pastel and the right colors, the degree of pressure to exert on the paper when painting, the tools to use for blending, and the best combination of line and color. Only experience will provide the skill necessary for blending *some* colors, leaving others untouched. And suddenly, the finished work appears like magic. The composition seems to take on a life of its own.

The Value of Imprecision

Whether limited to a specific area of the work or affecting all of it, pastel is a medium that allows a high degree of imprecision. What is imprecision? It is a technique that suggests a form without explicitly representing every part of it. For example, to portray a hand or a foot, a few lines are drawn and then color is applied. The sketch is purposefully left incomplete. Its imprecise nature acquires great authority when it succeeds in defining position and movement. As suggested on pages 20–21, pastel produces many sensations. When successful, an imprecise painting on paper can produce strong visual and tactile sensations, as if the pigment powder were suspended in air.

Francesc Crespo. In this case, the imprecise quality lends importance to the large mass of the body and brings out depth. The most distant and least important elements are the also the least precise.

PASTEL AS A DRAWING MEDIUM

Because its colors can be applied as lines, pastel can be considered a drawing medium.
And, because corrections diminish the quality of the final work,
pastel is one of the most demanding of the pictorial media.

Representing Three-Dimensional Objects on a Plane

The science of perspective involves the representation of elements with volume (three-dimensional objects) on a flat (two-dimensional) surface. Perspective dictates the basic lines of the drawing. Color and chiaroscuro will complete the appearance of depth and volume.

The three-dimensional objects around us can be reduced to simple geometrical forms, which can be projected onto the two-dimensional surface of the paper according to the rules of perspective.

The Geometry of Objects

Because the rules of perspective are easy to apply to simple geometrical figures, natural shapes should be simplified when they are projected onto a two-dimensional surface. A complex element of the subject being drawn can normally be blocked into a simple shape. Three-dimensional shapes that are frequently used include: cubes, parallelepipeds, spheres, cylinders, pyramids, cones, and truncated pyramids and cones.

The human body can also be reduced to simple geometrical shapes. The different parts of the body can then be blocked in using these shapes. The position, foreshortening, and movement of the figure can also be represented in this manner.

Principal Lines, Key Points, and Perspective

For each new subject, the principal lines, key points, important distances, groups of interrelated shapes, and proportions must be established by observing and applying the rules of perspective.

The *horizon* is an imaginary line located at eye level. The *point of view* is a point on the horizon line located in front of the viewer at the center of the *visual angle*. Imagine a framed composition. The imaginary lines

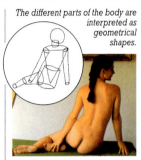

The different parts of the body are interpreted as geometrical shapes.

leading from the eyes of the viewer to the two points on the frame intersected by the horizon line constitute the visual angle. The point of view is situated at their bisector. It does not always coincide with the center of the drawing.

There are three types of perspective: *parallel*, *angular*, and *oblique*. For all of these, it is very important to determine the vanishing point or points. A vanishing point is the point at which parallel lines converge on the horizon line of a drawing.

In parallel perspective, there is only one vanishing point, which coincides with the point of view. The simplest method of projection, parallel perspective provides only a limited illusion of volume. In this method, horizontal and vertical lines remain parallel.

Objects reduced to simple shapes.

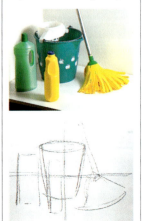

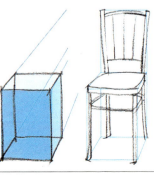

Examples of blocking in various objects.

Special Attributes of Pastel
Pastel as a Drawing Medium
Painting with the Fingers

43

1) Drawing a cube in parallel perspective: Establish the horizon line (HL). The vanishing point (VP) coincides with the point of view (PV). Draw lines to the vanishing point. Measure the distance (a). Draw the sides and bottom of the cube along the lateral planes. Two perpendicular lines should be drawn beginning from the two points where the ends of the side and bottom of the cube coincide with the vanishing point lines to define the rear face.

Angular perspective has two vanishing points. Because it allows the artist to project volume with accuracy, it is the most commonly used method. In angular perspective vertical lines remain parallel.

For oblique perspective, three vanishing points must be determined. It is the most precise method if not taken too far. Neither vertical nor horizontal lines remain parallel, and all lines converge at their respective vanishing points.

Establishing Planes and Verifying Accuracy

Once the various elements of the composition have been reduced to simple geometrical figures, their relationship to the different planes of the composition, from the closest to the most distant, must be established. The farthest elements will appear proportionally smaller. To ensure that your work will appear realistic, it is absolutely essential to verify the accuracy of both the perspective and the proportional measurements.

2) Representation of a cube in angular perspective: The horizon line (HL) is established. The closest edge of the cube is measured and two points are drawn (A and A') to define it. The two vanishing points (VP1 and VP2) are placed far apart on the horizon line. The angle forming the base of the cube should be greater than 90°. Vanishing point lines are drawn from A and from A'. The sizes of the two visible lateral faces of the cube are measured, proportioned and the lines (B) and (C) are drawn between the vanishing point lines to establish the sides of the cube. Vanishing point lines are drawn from the upper intersections of b and c; and their intersection (point D) closes the third and top face of the cube.

3) Drawing a cube in oblique perspective: Establish the horizon line (HL). All sides of the cube correspond to lines drawn to the three vanishing points, VP1, VP2, and VP3.

Preliminary Lines and Contours

Lines and contours are used to define the general scheme of the composition. Through them all forms are drawn in their proper place. Their purpose is essentially functional; only very experienced artists use artistic lines to establish the general compositional structure.

PAINTING WITH THE FINGERS

Pastel is essentially a finger technique. The fingers are the principal instruments used by pastelists to blend colors and create chiaroscuro. We have already mentioned the sensations experienced by the artist in the chapter on pastel as an intimate medium. We have discussed how to hold a stick of pastel and how to blend and mix with the hand. In this chapter we shall present some practical pointers for using your fingers to paint with pastels.

Any finger can be used to blend. The yellow marks show the parts of the fingertip appropriate for average to large-sized areas; the blue marks show the parts that are best for finer touches.

Blending and Mixing with the Fingers

Consider an artist's hand. There are various parts of it with which paint can be applied. Because the fingers are the most commonly used, they will be constantly covered with pigment.

The tips of the finger have oval forms of different sizes. When blending, the finger or fingers selected will depend on the surface to be covered. As shown in the photographs, any finger can be used. If the area to be covered is large, several fingers may be employed simultaneously.

The Thumb

The type of blending done with the thumb is special. Its joint allows for a good circular motion that can be excellent for representing volume. The thumb and its base on the palm of the hand work well for blending large areas.

MORE INFORMATION

- Pastel, an Intimate Medium **p. 20**
- Blending **p. 36**
- Gradation **p. 38**
- Pastel Painting in Practice 4. Blurring and Blending **p. 58**

The Hand

All parts of either hand can be used for blending and mixing, including the palm of the hand and the back.

Good Use of the Fingers

The finger is an immediate instrument. With your fingertips, you can control both the pressure and direction of blending on a colored surface. The finger should be lightly stroked over gradations and chiaroscuro to create a greater impression of volume. You can almost feel the volume being created. The sensitivity and versatility of this instrument make it the pastelist's first choice for painting.

Inappropriate Use of the Fingers

Excessive manipulation of color with your fingers can saturate the paper. Shortly after washing them, your hands generally recover their natural oils. Depending on your skin type, you may secrete more or less oil. Even this factor influences the pastels. Skin oils can cause the pigments to agglutinate, thereby hastening saturation of the paper.

Consequently, fingers are normally used in the last stages and for definitive operations. Otherwise, cotton is used in order to keep the surface less encrusted.

You can use two or three fingers at a time for blending.

An example of blending with the pinkie.

*1) The thumb joint allows circular blending.
2) The lowest part of the thumb can be used to cover large areas.
3) The entire length of the thumb can be used for even larger areas.*

1 2 3

Pastel as a Drawing Medium
Painting with the Fingers
The Color of the Paper

45

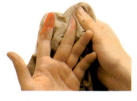

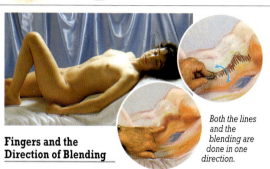

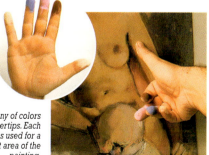

Both the lines and the blending are done in one direction.

Use a rag to wipe your fingers.

Fingers and the Direction of Blending

Proper direction is one of the most important aspects of blending with your fingers. Blending should always be done so as to create a most realistic chiaroscuro. Compare the subject with the artist's work. Note the arrow indicating the direction of blending.

Order of Use

An experienced pastelist will even relate the use of each finger, from pointer to pinkie, with the range of tones obtained from a color. The artist touches and strokes the color with each finger successively until an extraordinarily realistic representation of volume is achieved.

Wiping Your Hands

The disadvantage of painting with your fingers is that they will eventually get so dirty that they will affect the quality of your painting. They must therefore be wiped regularly. Let's suppose you decide to blend a color with a finger that already has

Note the harmony of colors on the fingertips. Each finger was used for a different area of the painting.

another color on it. What will happen? The two colors will simply mix, and this unintentional mix will spoil your painting.

To avoid this common but serious error, you should wipe your hands frequently. Normally a dry rag will do, but if there is a large accumulation of color on your hands, you will need a wet rag to eliminate the excess pigment.

Painting with Pencils and Stumps

Although pastel painting is normally done with pastel sticks, an entire work can also be done almost exclusively in pastel pencil, using stumps to blend. In this case, direct contact between the hands of the artist (Joan Marti) and the medium is reduced.

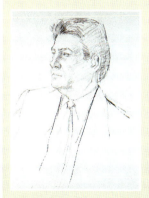

THE COLOR OF THE PAPER

Pastel can be applied on a support to produce an opaque layer completely covering the color of the paper, or it can be applied in a thinner layer that will allow some of the background color to come through. The artist can take advantage of the support by choosing its color according to the subject.

Deciding the Color of the Paper

Before choosing the color of the paper, the overall color scheme of the painting must be visualized. Some ground colors can be very flexible. Light, neutral colors, which can be either warm or cool, are suitable for almost any subject. It should be kept in mind that the color of the paper always influences the final color harmony of the work.

Using Empty Areas

Leaving an area of paper free of paint means incorporating the color of the paper directly into the overall color scheme of the work. Thus, the color of the paper takes on an exceptionally important role, and the pictorial effects can be pleasantly surprising.

Paper for pastel comes in a wide range, from neutral to intense colors. The color should be chosen to accord with the desired color scheme of the work.

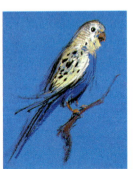
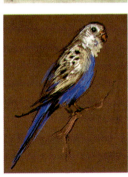

Here Ballestar has painted the same parakeet on different backgrounds. A white support tones down the highlights on the bird. A neutral background harmonizes well, as part of the plumage is the same color. A contrast can be obtained with a dark background color.

Raset has drawn the subject and suggested some of the drapery with loose lines in pure colors. The color of the paper is visible where no pigment has been applied as well as under some of the more tenuous lines.

Enhancing Tonality

Once the color scheme has been determined, the artist may then choose the color of the paper to enhance the general tonality. In this case, it will not be necessary to apply very much pigment in order to achieve the desired results. The painting quickly acquires the correct tonality.

When the color of the paper is chosen as a harmonizing element, it simplifies the complex process of relating all the colors of a work to achieve visually pleasing results.

If the subject is a group of metallic objects, as in the illustration on the following page, the dominant color would be gray. Some shade of gray should be chosen for the paper to facilitate the artist's work.

Painting with the Fingers
The Color of the Paper
Erasing

47

The color of the paper is intended to provide the hue of rusty metal.

Transparent Layers of Color

If color is applied lightly on a colored paper, the result will be a superimposed mixture. In this case, the color of the paper becomes very important.

Applying a Background Color on a White Support

When colors are applied very lightly on a white sheet of paper, blending them homogeneously will be simple. The color is fresh and appears transparent.

A background color can be applied on a white support paper. The pigment used can be ground from old bits and pieces of pastel. Naturally, the color of the background should harmonize with the general color scheme.

Jordi Segú.
The blue clearly shows all the colors of the gradation on the white background.

MORE INFORMATION

· Pastel Painting in Practice 2. First Colors **p. 54**

Choosing a Contrasting Color

Of course, the choice of color is sometimes based on other criteria. If the artist decides that the support should provide contrast, an intense color will be used.

As we know, color can add volume through chiaroscuro. Therefore, the color of the paper in relation to the tones of the chiaroscuro must also be considered. If a light-colored paper is chosen to harmonize, light and dark colors are applied, while the middle tones are provided by the paper itself. If dark or nearly black paper is chosen, all the colors applied will be lighter. The entire color scheme changes.

The Color of the Paper Can Heighten Contrasts Through Texture

The law of simultaneous contrasts (see pages 40–41) also applies here. How does the color of the support affect the colors added? Let's suppose we have a highly textured, clean surface. If we apply pastel lightly, the pigment will adhere to the elevated parts of the textured surface. The lower parts will remain free of color. Consequently, the colors of the support and the pastel are seen in juxtaposition as millions of little points, particularly if the two colors contrast with each other. Thus, the texture of the paper creates an optical illusion by simultaneous contrast.

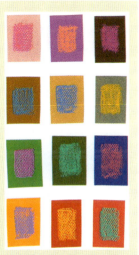

The texture of the paper creates by way of simultaneous contrast a vibrating optical interplay.

ERASING

The purpose of erasing is to eliminate a color either totally or partially. However, when done with pastels, rubbing out always leaves traces unless carried out on the most lightly applied colors. Obviously, the freshness of a pastel painting depends, among other things, on minimizing corrections or adjustments of all kinds. It is very important to get to know the possibilities and limitations of the erasing technique.

Correction

Any painting may require some correction. Errors can occur in composition, perspective, or (and this is a very common fault) the color applied can extend beyond the contours. Some corrections can be made by coloring over the mistake. Other times a painting can be corrected by changing the entire palette for a brighter or darker one. Alternatively, a layer of color can be applied so thickly that it completely covers anything—from mistakes to entire areas of the composition. But some types of mistakes require complete or partial rubbing out.

Powder that has not adhered will fall off easily.

Correcting by Erasing

In erasing a large area, the first step is to hold the painting upright and tilted slightly forward. Blow on the surface to dislodge loose powder; then rub a soft, clean cotton rag over the area to be corrected. The stroke should be in one direction without much pressure. At the end of the stroke, turn your wrist upwards to catch all of the powder that has come loose onto the rag and shake it off elsewhere. This procedure can be repeated until no more color comes off.

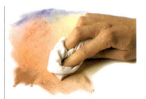

Erasing is begun with a cotton rag. The process can be completed with a kneaded eraser. The surface of the paper will never come entirely clean.

Rubbing out does not completely eliminate the color, but the area can be painted over if the newly applied pastel adheres well. One point to remember is that a surface on which color has been deeply encrusted and then erased will never look very clean.

Using a Kneaded Eraser

A kneaded eraser can be used to complete the rubbing out process begun with the cotton rag. This eraser can remove even more color from the surface of the paper.

You can also use a kneaded eraser to *open white areas*, which can be any size. This is achieved by erasing a colored area until the color of the support is visible. The kneaded eraser is the ideal instrument for this procedure because, as the name indicates, it can be kneaded into

Erasing can be done to create areas of lighter color.

Opening white areas on a blended gradation.

Color is rubbed off with a rag and then corrected with another color.

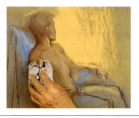 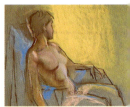

the brightness of the colors. But as a last resort, it can be useful to know that the adherence capacity of the paper can be increased after erasing by applying a layer of fixative.

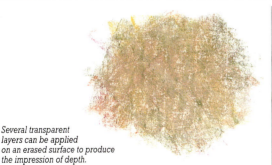

Several transparent layers can be applied on an erased surface to produce the impression of depth.

any shape and size to fit the area to be erased.

Surface Deterioration and Loss of Holding Power

All rubbing out processes lead to the deterioration of the surface of the paper, causing it to lose some of its capacity to hold pigment. It is suggested that you refrain from erasing in an excessively energetic or aggressive fashion.

Here is some practical advice. Drawing in the general lines of the composition should be done with very gentle strokes to allow for easy correction should it be necessary. After they have served their purpose, these lines can then be either painted over or completely erased.

Although pastels are generally opaque, the support or underlying lines can show through when the colors are blended sufficiently to form a thin layer. Therefore it is best to

leave areas where lighter colors are to be applied free of compositional lines. This will avoid unnecessary rubbing out.

Covering an Erased Surface with Color

Erased areas never become completely clean. Sometimes it is best to cover the entire area with one color as a base for further painting. Another option is to rub out the color entirely, and then change your palette for something darker or brighter than you had originally intended. Inevitably, there will also be times when the only solution is to give up, turn the paper over, and start again.

Using Fixatives to Increase Adhesion

Many pastelists prefer not to use fixatives because they can cause stains to appear in the painting and because they dim

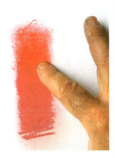

The area is erased with a rag, then fixative is applied. Finally, it is colored over and blended.

Using the Kneaded Eraser to Produce Plastic Effects

Erasing is not only used for correcting mistakes. In the example shown here, it has been used to open up white areas and to create a powerful sculptural effect. The result is quite spectacular, but it requires an ample knowledge of optical effects achieved through contrast.

Raset. Example of the sculptural effect produced with a kneaded eraser. The white spaces created with the kneaded eraser are major elements of the chiaroscuro.

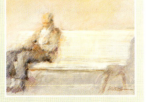

MORE INFORMATION

· Pastel Painting in Practice 4. Blurring and Erasing **p.58**

USING FIXATIVE

Until relatively recently, fixative was not used on pastel paintings.
Today, however, many pastel artists fix their works painted in pastel.
This chapter deals with the advantages and disadvantages of using fixative.

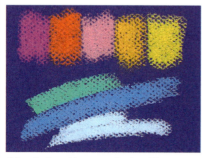

1) Pastel colors without an application of fixative.

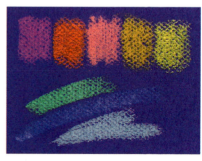

2) The same example, with fixative.
Note the patches of fixative on the pastel.
A layer of fixative reduces the brightness of the colors.

Fixative Stains

In the hands of an inexperienced artist, fixative can literally stain a work. This normally happens when too much liquid is applied to a certain area. If this occurs during the first stages of a painting, the results will not be disastrous. But excessive use of fixative during the final stages of a painting can reduce the freshness of the work due to the need to retouch the stains.

To avoid stains, hold the can of fixative about 6 to 8 inches (15–20 cm) from the surface of the paper and spray in circular or zigzag movements. It is vital not to concentrate on any particular area. The objective is to apply a very fine, homogeneous layer. Once this has been achieved,

Using Fixative with a Mouth Sprayer

This photograph shows an artist using a mouth sprayer to apply the fixative. It is best to experiment with this technique before attempting to use it on a work of art. After several trial runs, you should be able to apply a fine and homogeneous coat and to avoid stains.

Using a mouth spray.

the painting should be left to dry.

Also to make sure that the nozzle of the aerosol is kept clean.

Remember that fixative products are highly toxic. Always use them in a well-ventilated room.

A Layer of Fixative Can Reduce the Brightness of the Pastel

Let's experiment with fixative. First we draw several lines of pastel on a sheet of paper and then apply a generous layer of fixative. After the paper has dried, it is apparent that the

Always keep the nozzle of the aerosol clean.

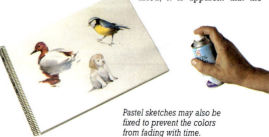

Pastel sketches may also be fixed to prevent the colors from fading with time.

The preliminary drawing executed with a light gray stick of pastel is fixed. Therefore, subsequent colors applied on top of the gray will not be soiled.

Once enough color has been painted, the artist applies a fine layer of fixative.

The final result, with all its wealth of colors. Colors have not blended with underlying colors. The finished work is not given a final coat of fixative.

brightness of the colors has been reduced. Note that an application of a finer coat of fixative lessens this effect.

Don't Apply Fixative to the Final Layer of Color

Pastel painters who use fixative in their works normally apply a layer over each application of color. Nonetheless, they leave the final layers unfixed in order to preserve their brightness.

Summarizing: Always Apply in Fine Layers

Fixative should always be applied in fine layers. This procedure prevents stains from appearing on the paper and maintains the brightness of the colors. Once the work is dry, you can proceed with the next layer of colors. Whenever you consider it convenient, apply another fine layer of fixative. And continue thus until you reach the final colors, which should be left untouched.

MORE INFORMATION
· Mixtures in Pastel **p. 34**
· Erasing **p. 48**

Fixative Increases the Adherence of Pastel to Paper

Fixative can stain or dull the brightness of a color. But it is essential for the artist to understand that the use of fixative increases the pastel's adherence to the paper.

A saturated zone that requires more color can be salvaged by applying fixative. If you then allow the paper to dry, there will usually be no problem in painting over the area in question.

It is not unusual to fix an area that has been erased or dirtied before repainting it. The color will adhere better and cover the errors without the danger of the underlying color mixing with the new application.

Fixing in Order to Prevent Mixing

The artist experienced with fixative can use it to prevent colors from mixing together.

When the painter wishes to paint over a previously applied layer of color, there is no alternative other than to fix the previously applied color. Failure to do so will cause the two colors to blend. By fixing the original color and leaving it to dry, the artist can safely apply a new color that will not blend with the original one.

A Matte Fixative

The natural finish on a pastel painting is matte. This characteristic must be maintained. Therefore, if a fixative is to be applied, it must leave a dull finish. There is no point in ruining a matte picture by applying a glossy fixative.

1) Yellow is applied over an unfixed layer of blue. The result: the two colors blend together.

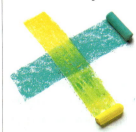

2) Yellow is applied over a fixed layer of blue. The result: the two colors do not blend together.

PASTEL PAINTING IN PRACTICE
1. SKETCHING

There are various stages that go into the execution of a work. First the subject is sketched. Next, color is applied to the most important forms. After that, selected elements can be enhanced, blended, or erased. Touching up is the final stage.

Framing, Composition, and Structure

Whether you choose a "ready-made" subject (a landscape, for instance) or decide to create your own (a still life or, perhaps, a posed model), *framing* is one of the most fundamental aspects of the composition. Framing, in this instance, means finding an arrangement that can fit comfortably within the format of your support. You can buy a framing device or make your own using two L-shaped pieces of cardboard (see photograph below). Alternatively, you can use your hands, your extended fingers, or whatever helps you isolate the portion of the scene that you find most attractive.

Once you have found the right setting, the next step is to sketch and block in the subject. With

Basic compositional lines.

several free strokes it is usually possible to reduce the picture's elements to simple geometric shapes. Fast sketches, without erasing or measuring, are most appropriate at this first stage.

From this point on, you will form a clearer notion of the picture's compositional elements and the distribution of color.

MORE INFORMATION

• Pastel as a Drawing Medium **p. 42**

Framing. Variable and fixed frames are available. Fixed frames come in standard stretcher sizes—for figure, portrait, landscape, and so on. You can make such a frame out of cardboard. It is very handy for choosing a portion of a subject and for calculating the size of the paper you will need.

Proportions and Divisions of Space

How do you transfer the preliminary studies to the support? Once you have framed the subject and determined the basic outlines of the composition, you must sketch the subject on the sheet of paper that you have selected for the final picture. Divide the various elements by means of a series of proportional calculations, applying your knowledge of perspective whenever the circumstances require it.

On page 43 you will find out how to obtain the right measurements. Then check how this is put into practice in the still life on page 53.

Measuring or sizing up is the basis for studying the proportions of the subject and the division of space. By observing the model, you can determine its size or the size of one of its important parts. Using this measurement as your basic unit, all other sizes can be deduced. Simply establish the relationship between your basic unit and any other part of the composition.

To summarize, several basic compositional lines center the subject on the paper, establish the scale, and determine the distance between the model and the artist. Next, all the relevant sizes are related to obtain proportionality, and a few more lines establish the distribution of

The measurement of height and width is vital to center the subject on the paper. In this example, the height is one and a half times the width. These measurements allow the artist to calculate the scale and to obtain the correct proportions for the size of the paper. It is important to measure everything to determine the interrelationship among the different elements. The height is two and a half times the measurement of the orange, the total width is one and a half times the total height, and so on.

the remainder of the composition on the paper.

The Preliminary Sketch: Strokes and Lines

Drawing preliminary sketches provides the artist with practice. In the initial work (when the artist concentrates on establishing the correct proportionality of the elements), draw with faint lines (using pastel colors akin to the final color scheme of the picture) to sketch the subject on the definitive sheet of paper.

Artistic stokes are generally executed with resolution; however, in the event of a mistake, any rectification will smudge the paper. With practice, free strokes can also be used for blocking in the composition. A few lines are enough to capture the basic structure, which can then be developed with more personal and resolute artistic lines.

Defining the Different Planes: Shadows

The next step is to define the most important zones of light and shadow. This can also be carried out using lines and shaded areas in a preliminary study.

There is another procedure for drawing shadows, which requires experience and fluency on the part of the artist. When the subject is illuminated appropriately, it can be rendered by means of a series of tones, also known as chiaroscuro.

The artist can either bring out the shadows by working on a light colored sheet of paper or, conversely, he or she can bring out the highlights by working on a dark colored sheet of paper. The colors used to obtain this effect should conform to the

general color scheme of the subject. In this case, the subject is sketched and the basic light and dark zones are established at the same time.

Defining the Limits of the Bodies

To sum up, the framing, composition, and sketch can be rendered by means of lines or shaded areas. Skill is required to draw the outlines of bodies with resolute strokes, capturing movement, and simultaneously revealing the artist's personality.

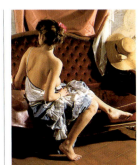

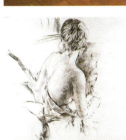

The subject is drawn with a burnt sienna pastel, a color that provides a magnificent base on which to work.

When a Sketch Becomes a Work of Art

An impromptu naturalness and spontaneity may develop when an artist sketches a subject that is not considered the definitive work. It is highly desirable, therefore, to execute sketches with free artistic strokes. Sketching nudes from life and capturing their movement, light and shadow, and proportions with rhythmic strokes is one of the best drawing exercises.

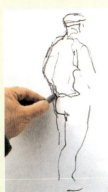

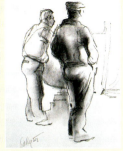

These first strokes create a masterly synthesis of form and movement. The gray and white tones are splendidly employed to lend the figure volume.

PASTEL PAINTING IN PRACTICE
2. FIRST COLORS

You must have a clear idea of what you want to achieve before applying any color.
Start by considering the relationship between the colors that you are going to use.
In other words, before covering the paper with color, decide all of the colors
that will be required for the subject.

Painting a Picture with Tones: Color Relationship

The artist has to assess the correct color scheme of the subject before applying any color to the paper. A sketch executed using tones defines the contrasted zones of light and shadow. It will also help the painter ensure that the colors used in the painting will produce a harmonious chromatic whole.

Can a Color Be Used to Harmonize?

The easiest way to establish the chromatic structure of a theme is to use one particular color and base the other ones on it.

Colored paper provides an excellent color base on which to paint, especially if you are

The color of the paper is very similar to the color of the melon.

thinking of leaving a lot of empty space.

The choice of color range will also define the palette, regardless of the number of colors selected.

The color of the paper and the palette are decisions that the

artist must make before beginning to paint. It is important to bear in mind that there is always one color that is more prominent than the others.

The Painting's Structure with Respect to Color

The sketch is the reference for applying color and lines. When the painter commences with a linear sketch, the faint lines mark out the various zones of color (and even tone) before the first colors can be applied.

Regardless of whether the color is opaque or transparent, always apply it according to the tonal zone, changing colors whenever necessary. And above all, you must have a clear idea of the highlights. They should be left untouched, so that the light colors, although opaque, can radiate all their pureness of color.

Observe how the zones of light and shadow establish the three-dimensional form of A. The shadows are shaded in B, providing the model with tonal planes. This can be done as a preliminary study.

MORE INFORMATION

• Drawing and Coloring with Pastel
p. 30
• Color Theory for Pigment Colors
p. 32
• Mixtures in Pastel **p. 34**

Pastel Painting in Practice 1. Sketching
Pastel Painting in Practice 2. First Colors
Pastel Painting in Practice 3. Enhancing

55

Sketching with Color

Even if you draw a linear sketch, the application of color over the preliminary lines lends the model more form, creates planes, and helps to develop the volume. As a rule, therefore, when you begin filling in a work with color, it is essential to ensure that the proportions of the objects in the preliminary sketch

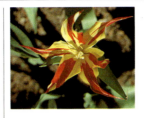

These compositional lines have been painted using each element's own color. The color is painted over the sketch.

The color must not be allowed to overlap and invade other areas.

remain correct. Many inexperienced painters often paint over the lines of the preliminary sketch. A misplaced patch of color, which stands out more than it should, distorts forms and may cause greater errors. Therefore, it is essential to stop from time to time, stand back, and observe the work. Check to ensure that the color schemes and the compositional structure remain intact.

Tonal Ranges of Pastel

It is relatively easy to obtain a tonal scale of grays. To obtain a tonal scale using all the colors of a subject is more complicated. The painter must choose not only the colors, but also their tones. Pastel colors are sold in a wide range of hues, a fact that makes the artist's work much easier.

Keep a Constant Eye on the Zones of Light and Shadow

When you begin to apply a color, you may lose sight of the overall color scheme of the subject. The best way to avoid this is by continuous analysis of each color with respect to the zones of light and shadow. And within each one of these zones, the colors must be linked together by gradations.

It is important to bear in mind that, if you do not establish the correct color relationships, the gradations and chiaroscuro will not look right and the impression of volume will diminish.

Try to examine the most important tonal zones through partially closed eyes. The blurry vision reduces the forms while allowing you to see the tonal planes more clearly.

Faint Color and Distinct Color

The first applications of color can be faint. The next layer can be applied more generously and thickly. The artist can also opt to sketch with patches of color and gradually build up the structure and color scheme.

The first colors are applied faintly.

The second layer is applied resolutely.

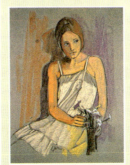

PASTEL PAINTING IN PRACTICE
3. ENHANCING

Color can be applied with intensity from the outset, or it can be added gradually after the first faint colors have been painted over the sketch. Let's look at how to build a chromatic structure. The objective here is to enhance the work with color.

Applying Color with Intensity

When artists apply color with intensity, they must continuously analyze the contrasts and tonalities.

The painter can alternate artistic strokes with coloring in accordance with the require-ments of the work. One aspect of the process that cannot be over emphasized is the *rhythm* of the

Here we can see various strokes and patches of different colors.

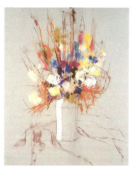

Compare the model with the pic-ture at this early stage. The evident rhythm has been obtained by applying the pastels in a set direc-tion. The essence of the whole has been conveyed by means of a series of strokes and colored patches.

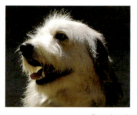 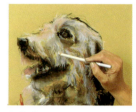

Drawing the hair of a dog.

work. Rhythm, the repetition of pictorial elements, is created by the direction in which the pastel is applied and the way in which texture is achieved with the chiaroscuro.

Rhythm, Direction, Texture

What exactly do we mean when we talk of rhythm? In the visual arts, rhythm is the relationship between lines, color masses, and areas of light and dark that heighten the portrayal of the subject.

The artist must use all of her or his technical resources: various types of lines and strokes, coloring, impasto, and so on.

Let's examine some examples. The direction of the light, exag-gerated by means of strokes, can be a pictorial element that lends the work rhythm.

Carefully study the intricate details of a subject. The hair of a dog, for example.

Now try to render the subject by reducing it to its most essential features in a few strokes. In this case, each stroke should convey the orientation of each tuft of hair on which the same *amount* of light falls. In other words, each one should possess that same color and tonality. This series of strokes, executed with resolution and in a specific direction, is what lends a work rhythm.

Achieving rhythm is not merely a matter of applying color. Rather, the direction in which the color is applied and the intensity of the strokes allow the painter to inter-pret the subject appropriately.

Heightening with Pure Colors; Using Available Color Ranges

The most important task at this stage of the work is to add more color. This will help to construct the chromatic framework of the painting. Of all the colors applied, those that are not to be erased will possess the same sharpness that the subject displays at present. For this reason, the colors to be applied now must be executed with resolution and cleanliness.

In order to enhance the color of a painting, it is best to not mix colors together. Use all the colors at your disposal as a substitute.

On Real Tonal Value

When a subject is not illum-inated by diffuse lighting, the contrast between the zones of light and shadow is very stark. A diffuse atmosphere doesn't produce as much contrast between the zones of light and shadow. In any event, to give a color a different tone is common practice for artists. It is up to the artist to decide how to interpret the subject.

Regardless of the choice of color, whether realistic or

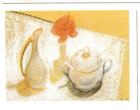

Esther Serra. Still Life. A work executed over a colored background.

The Color of Paper for Pastel

The artist can use the color of the paper as a counterpoint to the color of the subject. Moreover, unpainted areas of the colored paper can be used to harmonize. The color of the paper can also serve as an abstract element to lend the picture more interest or to create outlines. In other words, the virgin areas contrast with the painted areas to create a silhouette.

MORE INFORMATION
- Drawing and Coloring with Pastel **p. 30**
- Color Theory for Pigment Colors **p. 32**
- Mixtures in Pastel **p. 34**
- Pastel Painting in Practice 2. First Colors **p. 54**

imaginary, the contrasts will have to be adjusted accordingly. In other words, the painter must establish its tonal value. It all comes down to communicating a personal viewpoint, and there are many ways to achieve this goal.

It is important to bear in mind that the colors will lose part of their brilliance, be it due to the use of fixative or because of the inevitable deterioration of pastel over time.

Applying Color with Impasto

Impasto is used to enhance the colors, reinforce the final highlights, and touch up the painting. Impasto is thick applications of pastel. It can be achieved by painting heavy and superimposed strokes. Because pastel does not adhere easily to the paper and tends to saturate, the best way to maintain control is by using fixative or other techniques. Such procedures permit the execution of thick impasto.

Sketching, Filling in, and Enhancing

Watching an experienced pastelist at work is an extremely enlightening experience. The observer can see how essential it is to practice and master the medium and the accessories. With a few strokes the subject is sketched, shading defines the masses, and the impasto enhances the effects. A few structured lines and colors are enough to obtain a precise representation, which can then be further developed.

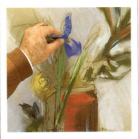

Here the artist outlines the flower by filling it in with color.

In this case, the artist outlines the flowers in "negative"; the shape of the flowers is defined by darkening the area surrounding them.

Respecting the Planes: Painting with Tones

The artist must take great care when applying a thick layer of color if the result is to be correct. In other words, it is important to respect the different planes and their corresponding tone. The color contrasts needed to convey a volumetric representation of the painting's elements must be identified.

Respecting the Highlights

This is one rule that must always be taken into account. Whether you are sketching, painting with faint shaded areas, or applying color with intensity, the highlights must always be respected. They must be dealt with so that each one appears as bright as is required. It must conform to the relationship among the other colors used in the painting.

An Unblended Work

It is possible to paint a pastel picture without blending or blurring with a stump. Instead the work is enhanced from the outset with pure, unblended colors. This kind of work is known as a colorist painting.

Ballestar. The volume of the objects is achieved with short strokes, pure colors, and all manner of shades and hues.

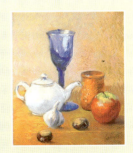

PASTEL PAINTING IN PRACTICE
4. BLURRING AND ERASING

Some works require very little use of the stump or finger to blur or erase.
The colors in others have been manipulated with the artist's finger or other instrument.
Blurring is always carried out in order to lessen contrasts.

This stroke stands out more strongly against a dark background.

Blurring:
Reducing Contrasts

Artists blur whenever they want to reduce the sharpness of contours. This simple procedure allows them to soften the contrasts produced by the sharpness of shaded or juxtaposed areas of color.

The procedure consists of spreading a lighter color over a darker one, if the aim is to lighten the area. Conversely, if the aim is to darken an area, the darker color is spread over the lighter one.

A work painted with two colors, pale yellow and gray, on a sheet of cream-colored paper. The volume is achieved using only these colors and plenty of blended gradations.

Blending the line by rubbing the finger from left to right until a suitable degree of contrast is obtained.

Finally, it is important to remember to spread the color *in the same direction.*

Gradated Blending

One important aspect of erasing methods is the gradation

The rag can be used to remove color.

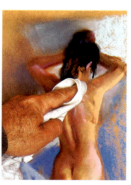

technique. Depending on the degree of fusion you wish to achieve, the blending should be executed on the line separating two colors.

Erasing and Blurring

The artist can erase certain zones of the picture to rectify errors. No matter how carefully a painting is planned in advance, a color applied on the paper may appear inappropriate. This can be corrected by rubbing the area with a clean cotton rag, taking care not to dirty the surrounding colors. The kneaded eraser can also be used, but is usually not necessary. The new color is often enough to conceal the mistake.

Sometimes it is necessary to use a stump to remove the color. Alternatively, this can be accomplished by using a cotton rag rolled around the index finger.

Synthesis and Details

The painter continually outlines the major elements and adds details. With very few lines it is possible to define the most relevant parts of the subject. Then some detail is added to give the subject more character.

An example of synthesis can be found in the defining lines of a picture. They are the ones that provide the work with personality and meaning. Such strokes, executed with confidence and resolution, lend the work rhythm. Some of these initial lines will remain in the picture at its conclusion.

More detail and color can be achieved with additional strokes and color, or even by erasing.

Pastel Painting in Practice 3. Enhancing
Pastel Painting in Practice 4. Blurring and Erasing
Pastel Painting in Practice 5. The Final Touches

59

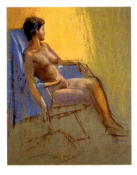

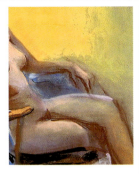

Erasing and applying more color corrects the outline of the hand.

A pastelist always paints a picture by following a set of general guidelines. The essence of the subject must be summarized with a line or a shaded mass of color in order to convey movement, light, and so on. Then, when necessary, the artist may tone or erase certain parts, searching out the contrast and tone required.

Chiaroscuro

Blending and gradating are the techniques required to obtain a chiaroscuro effect with pastel. Erasing can be carried out on a colored area.

In order to achieve an optimum representation of volume, it is important to know how to create a chiaroscuro (pages 40–41). The

effects must comply with the tones that are observed in the model.

Correcting an Outline

An outline can be rectified by erasing it. All the artist need do is blend the erroneous line and then redraw it. Nonetheless, there is another option. Depending on the circumstances, it is also possible to correct a profile *by painting in negative*.

A light-colored profile can be rectified by applying a dark color to define the line more suitably.

Conversely, a dark outline can be corrected by painting over it with a lighter color, thus modifying the line as much as is desired.

Continuous Checking

It is important to carry out constant checks on the development of the contrasts. The adding of a tone or the introduction of a new color can change the chromatic structure of the work. Therefore,

be observant in order to ensure that everything is *adjusted* properly.

Adding More Color

Having attained the correct contrast and tone, the artist can return to applying color. The various stages of a sketch—adding the first colors, enhancing, and erasing—should not be considered an obligatory sequence. However, each stage is essential for a fully realized painting. The precise sequence is determined by the creative process—the interrelation between the artist and the work. Transitions occur quickly and spontaneously. The painter's fingers can work delicately or they can be used with resolution and almost with violence. Thus, the work is a continual cycle of sketching, coloring, and blending —all under the guidance of the artist's natural instincts.

Coloring, blending, coloring.

Felipe Santamans. Still Life. *A "paint-painting" executed in pastel and with a mastery of chiaroscuro.*

A Blurred Work

The structure of this painting is based on the blending technique. Only the black lines that outline the figure are left unblended. With this method, the artist provides a suggestive interpretation of his subject.

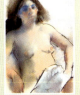

Francesc Crespo. Nude with a Towel.

MORE INFORMATION

- Blending **p. 36**
- Gradation **p. 38**
- Special Attributes of Pastel **p. 40**

PASTEL PAINTING IN PRACTICE
5. THE FINAL TOUCHES

The last stage of the work is adding the final touches such as
highlights, reflections, and subtle hues in order to give
extra density and definition to the subject.

*Olmedo. Once the work is finished, the artist can see any mistakes
he has made. If he decides to erase part of the picture, he can
go over it once more.*

The Final Touches

Before commencing the final stage of a painting, many artists take a short break. Some prefer to put the painting aside for an even longer period. It is not essential to do this, of course. But this procedure does provide the painter with an opportunity to observe and study the work in a fresh light.

Any errors that the painter might have made can be located. Some mistakes may stand out so clearly that whole areas may have to be erased.

Such errors are due to various factors: the artist can become too absorbed in the work or may have yielded too much to impulse. Any rectifications at this point normally muddy the colors. Knowing how to correct oneself during every stage of the process is the best way to learn.

Ballestar. Compare the subject with the interpretation of the highlights created by the artist.

Shine and Tonal Value

In a tonal painting, the model's highlights are the brightest parts of the picture. Although everything in gradation must be in its place, the highlights are touches of color that are intended to stand out. As the most prominent parts of any work, they should be executed with the utmost care.

The artist must study the color of each highlight before painting. If it is necessary to establish a correlation between the patches of color, the highlights must be regarded as the maximum points of light; the other colors must be kept in line with them.

Highlights

Highlights do not always have the same intensity of light. Some reflections are so brilliant that they appear to glow. Every object and figure gives off highlights in accordance with its reflective capacity. It is impossible, therefore, to provide a specific rule. The properties of each surface must be studied.

Surfaces and Highlights

Surfaces such as glass or mirrors reflect lots of light. Bottles, glasses, or any object made from glass produce strong reflections when placed in a powerful spotlight. This is true of mirrors as well, provided the angle of the reflection allows the observer to see them. A string of pearls produces a host of high-

Miquel Ferrón. The highlights have been dealt with here with the greatest subtlety, in accordance with the style of the painting.

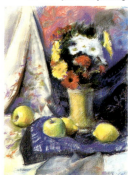

Ballestar. This is a perfect subject for painting very intense highlights.

Pastel Painting in Practice 4. Blurring and Erasing
Pastel Painting in Practice 5. The Final Touches
The Subject and the Artist's Aim

61

Ballestar. Highlights and transparencies of glass.

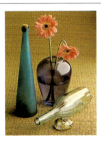

Ballestar. Reflections and highlights on the surface of water.

Ballestar. Highlights in a cat's eyes.

Reflections, Colors, and Shades

Although highlights are the consequence of light that strikes an object, the illumination of the entire setting also affects the reflections. Every type of illumination has its own particular color characteristics, which bathe the entire subject and lend a predominant color to it.

Other factors that characterize a highlight are the type and the color of the object's surface and the color of the surrounding objects.

Even the dullest surface acquires a slight hue from nearby objects. In fact, all objects contain a certain amount of color from surrounding objects.

An observant artist can convey all of these subtleties. Thus chiaroscuro can be used to enhance the entire chromatic structure of the work.

lights. Marbles give off an intense highlight. Even human and animal eyes produce highlights.

Depending on the observer's point of view, an expanse of water can produce distorted images as well as highlights. This applies to examples such as the sea, a puddle, a wet street after a rain shower, a lake, and so on.

Vitrified surfaces, such as glazed ceramics and enamels,

tend to reflect characteristic shines.

Varnished wood also produces highlights because its surface is polished. Other examples of items that produce highlights include articles made of copper or gold, coins, chains, and so on.

Silk and satin also reflect light. But not all drapery produces significant highlights.

Terra-cotta barely gives off any light.

The highlights produced by skin vary according to its shade, the amount of oil on its surface, and the atmospheric illumination.

Conveying Highlights with Color Impasto

Highlights are the whitest reflections on an object. As a final touch, they can be created with a thick color impasto. And as always in art, depending on the painter's aim, they can be used to increase vividness or even to soften the work.

Ballestar. These highlights, executed with impasto, convey an intense chromatic interpretation.

MORE INFORMATION
• Pastel Painting in Practice 4. Blurring and Erasing **p. 58**

Ballestar. Note the strokes and patches that depict the highlights and reflections produced on each of the objects. In addition to the effect of the chiaroscuro, volume has been enhanced by the inclusion of colors in the highlights.

THE SUBJECT AND THE ARTIST'S AIM

There are various genres in painting: the still life, the landscape, the urban landscape, the seascape, the portrait, the nude, the dressed figure, animals, and so on. Thanks to the exceptionally wide ranges of colors available in pastel, the artist can paint any subject in any genre and interpret it according to his or her own personal style.

The Artist and the Subject

An artist can be inspired in a variety of ways. The stimulus may originate from within the immediate environment or from outside it. Some subjects can be painted as is, while others need to be composed before they are painted. Notwithstanding, it is the artist's personal interpretation of the subject that most determines the result.

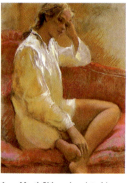

Joan Martí. Although painted in a warm range of colors, vigorous lines bring this work force and character.

Interpretation

A work can be figurative or abstract. The aim of a figurative interpretation may be realistic, romantic, impressionistic, or expressionistic. Nonetheless, any figurative painting can contain as much abstraction or elaboration

Precise drawing endows this painting by Olmedo with his special point of view.

as the painter desires.

It is essential to select the right harmonic range of colors for the interpretation of the chosen subject. The psychological associations of colors are well known. For instance, the use of soft colors is more appropriate for a romantic painting.

But interpretation is not based solely on the painter's choice of colors. The way in which they are worked (texturing, juxtaposing) will also convey very different feelings. A painting containing

Miquel Ferrón defines perspective and volume with reiterated and vigorous strokes.

Carlos Alonso Eugenia is a masterful pastelist. Applications of color and the techniques employed give rise to a unique painting.

stark contrasts would not be appropriate for a romantic interpretation of a subject.

Absolutely everything, from the choice of the subject, its framing, composition, choice of colors, texture, light, and atmosphere expresses the artist's aim—his or her particular interpretation.

Intimate Painting

Pastel is the ideal medium for painting intimate scenes. The Impressionists captured everyday domestic scenes in pastel. All the elements in the interior portray the atmosphere. In an intimate work, the surroundings should convey a great deal about the depicted figure's mood.

An artist can interpret an intimate scene by using pastel techniques to create a suggestive atmosphere.

The painter tries to predict the possible effects of a certain type of illumination. This is paramount to creating the right atmosphere.

The quality of the light in an intimate painting is also

Degas. Woman Combing Her Hair.

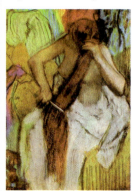

important. Depending on the time of day and whether the light is natural or artificial, the artist can heighten or soften the effect of his work. The choice depends upon what the artist is seeking to achieve. Whatever the aim, the chosen atmosphere should envelop the figure.

Arrangements and Montage

Simulation is widely used by artists. Arrangements are created to convey a specific environment or situation.

The most simple arrangement is the still life. However, a dull still life is very different from one that reveals a rich interplay of colors and forms. A more sophisticated still life requires a backdrop, such as drapery, that displays the chosen objects to best advantage. Next, the scene should be carefully studied and rearranged if necessary.

The artist can go beyond a mere backdrop, introducing portions of various other scenes and objects in an attempt to heighten interest and probe more complex concepts.

A nude, surrounded by the type of drapery used in an Egon Schiele painting transmits anxiety This impression is achieved by the artist's expressionistic stroke and choice of colors. These technical effects, in combination with the subject's pose and the overall composition, capture the painter's own special view of the model.

In a symbolic representation, it is the mere association of ideas that conveys the artist's unique viewpoint. A figure surrounded by concrete, for example, is synonymous with asphyxiation, confinement, unnaturalness.

Creating Color Contrasts

The choice of colors for a painting is one of the fundamentals of interpretation. No two artists will paint the same model in the same way. There is an infinity of possibilities for relating colors to one another. The artist can use subtle harmonies without harsh color or tonal contrasts.

Another option is to create striking color contrasts using complementary colors. Or the painter can tone pure colors with the use of neutral colors.

If the artist cannot find the desired contrasts and subtleties in a real-life scene, she or he may have to create them. This is the moment in which the capacity for abstraction allows the painter to alter the planes, dramatize the colors, and introduce personal associations with chromatic and expressive force. But there is also a more radical solution: to place the subject within an atmosphere that is not normally associated with it.

The Pastel Medium

Color contrasts can be obtained using one of two techniques: the value painting technique or the colorist technique.

Value painting conveys atmosphere and chiaroscuro by means of blending and gradations.

The colorist approach entails the sole use of pure colors, taking advantage of the wide ranges available in this medium. A colorist work displays the strength and purity of the colors in all their glory; and one should remember that a soft pastel is

José Luis Fuentetaja. An interior with a figure. The painter has created a more diffuse, less contrasty atmosphere around the figure. Note that the surroundings are painted with minimal detail.

made up almost entirely of pure pigment.

In practice, the artist usually combines both techniques, especially when colors are balanced through blending.

| MORE INFORMATION |

- The Still Life **p. 64**
- The Landscape **p. 66**
- The Urban Landscape **p. 68**
- The Seascape **p. 70**
- The Figure in Pastel **p. 72**
- The Portrait **p. 74**
- The Nude **p 76**
- The Dressed Figure **p 78**

On the Separation of the Genres

The still life incorporated within a broader subject: In *The Tub* by Degas, the objects on the left form an independent work. However, the nude in the tub is the true central subject of the painting. The still life here has been included as a secondary element in the composition. *The Great Poppies*, by Emil Nolde, is a true profusion of color. This painting is a landscape with flowers. Indeed, the flowers are situated within the landscape's very foreground.

Any landscape that included figures can be regarded as both a landscape painting and a figure painting, depending upon which elements appear most prominent.

And what would you think of a seascape in which the sea is scarcely visible? The division between the genres must be regarded as an open-ended system of classification.

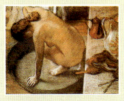

Degas. **The Tub.**

Emil Nolde. **Great Poppies.**

THE STILL LIFE

A still life is a collection of everyday objects. It may contain
fruit, glasses, bottles, keys, a dish cloth, all manner of utensils, flowers, and so on.
But, by definition, all of the objects in a still life must be inanimate.

Learning to Compose a Still Life

Though the still life is an excellent genre to begin painting in any medium, it is especially suited to pastel. This is because it

1. The elements are too bunched together.

2. The elements are too dispersed.

3. A well-balanced composition that directs the spectator's attention to the center of interest. The structure of the composition is made dynamic thanks to the way in which the bunch of grapes is positioned at the front (compare it with 1), thus establishing a bridge between the spectator and the rest of the still life.

The balance of color. The compositional structure is absolutely linear in this case. This is compensated for by a splendid chromatic equilibrium.

is a medium that lends itself to both drawing and painting techniques.

Every home contains objects that can be grouped together to create an interesting still life. In addition, they can be set up in a small space—on a table, in a wooden drawer, a chair, and so on.

The best choice of composition and lighting for the objects in a specific still life provides an invaluable exercise in arrangement and illumination.

One rule is to look for a balance among the elements of the composition. In other words, the artist must search for unity among the various objects. The elements must be placed where they will stand out to best advantage.

A well-defined composition can lend rhythm to the work. Rhythm arranges, harmonizes, and unifies. The pastelist can achieve rhythm by means of interesting artistic lines, color, and contrast. Some artists have painted still lifes with more daring compositions, carrying the lines and perspective to their most extreme limits. Painters always seek to give a personal touch to the compositions and the color structure of their still lifes.

Perspective in the Still Life

The use of perspective (parallel and angular) allows the artist to obtain a correct compositional study, provided the still life is not arranged in an unnatural way.

In this genre, there is a profusion of glasses, bottles, plates, jars, and so on, in which the circular and cylindrical forms are repeated. It is useful to know how to project the perspective of a circle and, by extension, that of a cylinder.

Eight reference points.

The circle in parallel perspective.

The circle in angular perspective.

The cylinder in parallel perspective.

A circle is enclosed within a box, and a second, smaller square is enclosed within the circle. Note the reference point used in the plan. It is useful to know that a circle projected in parallel and angular perspective invariably produces the same figure.

A cylinder in parallel perspective is begun with a conventional parallelepiped projection (an elongated cube). Then the circles that connect to either end of the vertical lines are added.

Lighting

Lighting is an equally important element used to balance colors. The artist can control the light of a still life, especially if it is artificial illumination, and adapt it according to his or her needs. A variety of chromatic differences can be obtained with the same objects under different types of illumination.

Light and shadow are essential in a still life in which the foreground contains sharp contrasts and clearly delineated shapes. The placement of the shadows within the composition is particularly important with direct lighting.

Tonal Variations

In order to get used to painting variations in tones, it is best to paint easy subjects at first and then gradually take on

more difficult motifs. The beginner should start with charcoal, which allows all manner of gradations on paper. The best way to learn about color is to paint a more complex sketch in a single color. With this approach it is possible to execute an entire range of gradations. If, in addition, you add touches of white chalk for the highlights, the volume will emerge from the chiaroscuro.

Round blobs of color and a little line perfectly convey the essence of the anemones. Attaining such a high degree of skill requires a great deal of practice.

Odilon Redon. All his floral works painted in pastel appear to be explosions of color.

Gradually, you can add more colors, first with tonal ranges of a single color, then painting with several colors.

Applying color through tonal changes (using a stump and the chiaroscuro) or even using pure colors are two options that produce very different rhythms.

Floral Motifs: Capturing Color

Floral motifs constitute an authentic subgenre of the still life. Flowers are the best subject for practicing artistic strokes and getting started with color. Flower arrangements provide an excellent basis for developing your technique in a versatile medium.

In a subject that poses no significant problems of perspective, depth in a painting is achieved through color.

Flowers provide the artist with a subject that can be treated energetically. Perhaps this is the greatest difficulty involved in painting flowers. Flowers that appear over-worked quickly lose their bright colors. Thus, your ability to produce a spontaneous pastel painting of flowers is the best measure of your progress.

Francesc Crespo.

Ballestar.

THE LANDSCAPE

The landscape as a work of art is not merely an attempt to explore outdoor space and its relationship to light. A landscape painting conveys the artist's feelings for nature and for a particular place. The Romantics painted landscapes that were more spontaneous than the studied, monumental conceptions of their Neoclassical predecessors. The Impressionists continued this liberating movement by attempting to capture the disassociation of colors caused by fleeting, ever-changing luminous phenomena. The Fauve school painted landscapes containing splotches of blatant color. The development of the landscape has since moved on to more abstract representations, naive art, and Surrealism.

Liotard (1702-1789).

Mir (1873-1940).

Sanvicens (1917-1987).

The Landscape Throughout History

The landscape genre has developed in accordance with society's attitude toward nature and the innovations of the great masters who interpreted it. Today, it continues to be one of the most popular genres in pastel painting.

The panoramic view of Geneva painted by Liotard, which in addition includes a self-portrait, is a unique work of art. The technique used is very different from other pictures painted in other periods. All works of art possess elements that indicate the period in which they were painted.

The works by Mir and Sanvicens, which are more contemporary, display different color choices in highly personal interpretations.

The Composition of a Landscape

To obtain an attractive landscape composition, two fundamental factors must be borne in mind. First, the artist has to seek out a setting that contains well-balanced chromatic masses. Secondly, the artist must study the landscape and differentiate its planes.

In a color composition, balance is attained by the size and relationship of the chromatic masses—in other words, by their value (whether color or tonal) and the distance between them. Study the graphic examples reproduced below. The second option is far more balanced than the first, and the center of interest is not displaced as far to the left.

Depth of a landscape is achieved through the modulation of the colors, the sharpness of the outlines, and the proportions of the objects.

By studying the subject, the artist is able to mark out the different planes that are to be included within the picture. Each one of these planes should be granted a different degree of contrasts and textures. The elements in the foreground are proportionately larger, have the most detail, and display the greatest color contrasts. As the elements recede into the distance, the smaller they appear, by their fuzzier their outlines, and the fainter their colors. This is due to the effects of the intervening atmosphere.

The foreground, on the right or on the left of a painting, should contain a clearly detailed, well-modeled element—a tree, perhaps. As the eye looks into the distance, the trees appear smaller until they can no longer be made out. Distant mountains are not seen in their true color, but are toned by the effect of the atmosphere.

To sum up: the foreground has more detail and the contrasts are heightened. As the planes recede into the distance, the elements become less sharp and

The setting. Balance between the chromatic masses.

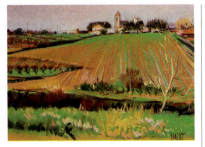

Olmedo. Note the size of the tree in the foreground. Now see how the other trees are gradually reduced in size as they recede into the distance, the farthest ones being represented by tiny blobs of color.

the contrasts diminish.

The intervening atmosphere gradually lends the most distant features a bluish gray tone, depending on the light.

Depth. The use of a prominent foreground element (in this case a tree) provides a great sense of depth, due to the contrast of its volume with the group of houses.

Guidelines

It is difficult to provide general guidelines, but not only because there are exceptional settings. The way in which an artist works allows him or her to turn a difficult or banal subject into something highly attractive.

There are several points that should be taken into account when trying to locate an interesting landscape. It is indispensable to balance the chromatic masses as a way of creating a visual center. Furthermore, it is easier to achieve a sense of depth when there are elements that allow the painter to establish proportion and differentiate the planes.

Beginning to Paint What You See

The best method to get started is to simply reproduce the colors you see. An artist who masters color can interpret a landscape by looking not at reality but by seeing how the chromatic structure can enhance his version. The choice of colors for the same landscape can vary radically from one painter to another.

There are three basic elements most commonly featured in a landscape: vegetation, sky, and earth or rocks. Depending on the

light, all these elements can acquire very different colors and hues. This is further complicated by figures, flowers, and animals. Clearly, every subject requires its own particular selection of colors.

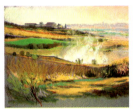

Olmedo. Detail. Elements in the distance appear more fuzzy.

The Aim and the Choice

The chromatic structure of a painting conforms to the artist's interpretation. The setting, the time of day, the season of the year, and so on, are factors that influence the interpretation. The creativity of each artist involves locating those elements that will best explain and provide coherence to the landscape. Given that colors transmit sensations, it is not unusual for the artist to heighten a feature (which another might consider secondary), and thus achieve a unique interpretation.

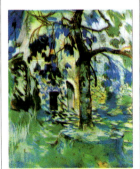

Mir. Landscape. An impressive work painted with cool colors.

MORE INFORMATION

· The Dressed Figure **p. 78**
· Animals **p. 80**

The Sky

The sky is the most infinite plane of all. Producing an effect of depth demands ephemeral colors, with abundant blends and gradations. A clear sky can be executed with a simple gradation (see page 39). Cloudy skies are more complex. They must be studied in order to observe two types of shadows: those that are cast on the ground and the shadows of the clouds themselves.

The artist should use chiaroscuro to express the light filtering through clouds. Executed correctly, this produces depth. A flat painting would require other techniques.

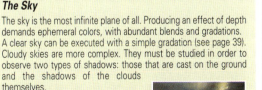

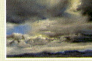

Two examples of skies painted with pastels.

THE URBAN LANDSCAPE

An urban landscape is defined as one containing streets, sidewalks, squares, and buildings.
The earliest known urban landscape is the *veduta* genre, which was widespread in Italy during
the seventeenth century and was later adopted by the Venetian school.
A *veduta* is an urban landscape in perspective, be it real or imaginary, which evokes
atmosphere. The current-day equivalent is the urban landscape of big cities.

Perspective

One of the important aspects of an urban landscape is perspective. Without the correct perspective, the composition and depth are doomed to fail. Most sketches of this type of subject are done in parallel or angular perspective.

Since the vanishing points are often situated outside the border of the paper, it is essential to establish certain guidelines in order to draw in perspective.

Note the adjacent drawings. The direction of the lines and their convergence points are obtained by enclosing the house within a box. Once their directions have been established, the vanishing lines can be drawn.

In an oblique perspective, three planes of the object are depicted and there are three vanishing points.

Slanted Planes

The coexistence of several slanted planes within a single subject requires the use of one or more additional vanishing points. In this case, the drawing is resolved thanks to a special horizon line.

The vertical horizon line.

If in a horizontal plane the diagonal lines converge at the horizon line, in a vertical plane the diagonal lines converge at a vanishing point on the vertical horizon line.

The Composition of the Subject

There is an infinite number of ways to draw an attractive urban landscape. It could contain the glass façade of a modern building with all its reflections and highlights. Equally, it could be a simple skyline of the city's

rooftops, executed in gray. It could even be a monumental urban landscape such as, for instance, the Houses of Parliament or the Statue of Liberty.

The artist can paint any urban landscape; but the elements chosen to personalize the subject must be studied carefully. Choice of format will influence the result, as will the height-width relationship. At times, the painter may prefer a more daring setting with slightly forced perspectives or even gigantic foregrounds.

The Tonal Sketch

Once the artist has chosen an attractive setting, it is very useful to draw a preliminary tonal sketch of the subject with the right perspective. The choice of paper and colors must be simple.

Regardless of the interpretation that you want to give the landscape—realistic, impressionistic, or somewhat abstract— you must choose the colors very carefully. The picture's color scheme is based on the color of the paper, the choice of pastels, and the way the pastels are applied.

The color synthesis of a subject suggests the type of relationship the colors should have. You may decide on a warm, cool, or a neutral range of colors, just as you would do for any other subject.

Neutral Palette: Gray Rainy Days and Concrete

In the case of an urban landscape of a big city it is more convenient to widen your palette and include neutral colors. This advice is not intended solely for pictures of cloudy or gray, rainy

These slanted lines are used to sketch all the linear elements of the subject correctly.

days. Asphalt and concrete are synonymous with large modern cities, so they must be prominent in the color scheme of an urban landscape.

The colors of urban elements, from buildings to streets, constantly change according to the light, which in turn depends on the climate. In certain pictures, a particular element (asphalt, concrete, bricks, an old or new building) is the main subject of the painting and gives it a predominant color.

These urban materials, paving stones, traffic lights, walls, and so on, assume a very distinctive aspect on rainy days. There are many reflections and everything acquires a grayish appearance that is very appropriate for use with neutral colors.

City Landscapes and Rural Landscapes

Although the city landscape and the rural landscape are very different from one another, the problem of perspective affects both in the same way. The artist must practice sketching the subject and balancing the colors.

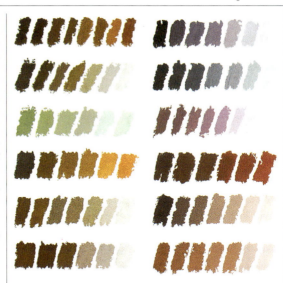

The neutral palette. Examples of colors manufactured by Sennelier. They include some earth colors (ochre, sienna, umber), grays, greens and neutral blues.

In both the urban and the rural landscape, the atmosphere should be transmitted in the same way the painter would approach any outdoor subject. It is essential to clearly define the different planes. The artist has to plan how much color he or she will include in each one. Above all, it is important to maintain the right proportionality throughout the entire process.

MORE INFORMATION

- Pastel as a Drawing Medium **p. 42**
- The Landscape **p. 66**

"Picture Postcard" Urban Landscape Painting

There are buildings, sculptures, and an extremely long list of assorted elements that have become symbols that immediately identify a certain city:

Here we can see an urban landscape whose main subject is one of the most representative music halls in Barcelona.

A view of the Eiffel Tower allows the spectator to identify the city of Paris from the outset.

Typical tourist boats on the Seine River and the Cathedral of Nôtre Dame provide additional symbols of the French capital.

Olmedo. El Molino.

Olmedo.
View of Paris with the Eiffel Tower.

Olmedo. Bateau Mouche.

THE SEASCAPE

Any composition that includes the sea is regarded as a seascape. The history of the genre began in the Low Countries during the sixteenth century. Later, it also became popular in Italy and France. The English Romantic painters, particularly J.M.W. Turner, approached the genre with vigor and imagination. With the advent of Impressionism, pastels were recognized as an ideal medium for capturing aquatic scenes. The exciting changes that took place, from the choice of setting to the composition, were further developed by the pointillists. The beginning of the twentieth century saw a revival of the genre thanks to the interest of the Fauve painters.

Drawing a Seascape

The drawing problems associated with the seascape can be resolved with the use of parallel and angular perspective. Oblique perspective is only used for very unusual paintings.

The horizon is the line that separates the sea and the sky. Depending on where we stand, we see either a broad stretch of water (when the horizon line is high) or a narrow stretch (when the horizon line is low). All the elements in a seascape must be situated in correct proportion with respect to the horizon line.

This rule must also be followed with the utmost care if groups of houses are to be included. In this case, it is best to deal with the picture as if it were a landscape.

And, like a landscape, the seascape must have a well-balanced color scheme.

The Perspective of Boats

In order to draw in a seascape an element as common as a boat, you must first "block" it in. In other words, the artist looks for a simple geometric form within which the object can be enclosed. If the lines of the box run correctly to the horizon line, the next step involves drawing the boat within the box. As you

can see in the example, the best shape for this craft is a parallelepiped. This procedure is similar to the one used for the cube. The horizontal size of the parallelepiped is greater than that of the cube; in addition, the faces are rectangular. Nevertheless, all the artist need do is alter the drawing of the boat in accordance with the box. Once the drawing has been completed, the correct colors will augment the illusion of depth.

The Horizon Line: Depth

The horizon line in a seascape divides the sea from the sky. Often, a cloudy or clear sky and the horizon line are the most distant elements in a seascape. On a clear day, they may appear very sharp. On a stormy gray day, everything appears very blurred. The artist must study these aspects in order to apply the colors that will create the right atmosphere in the painting. A well-defined background gives a seascape depth.

A Seascape Containing a Large Stretch of Water: Painting the Sea

To paint the sea, or any other object, the artist must use keen powers of observation. The main difference between the sea and other subjects is that the sea is ever-moving. Regardless of

whether it is calm or rough, it is essential to capture this most essential aspect in the picture.

In addition to light, the painter must study the color of the sea and the characteristics of its transparency.

Not all seas have the same color. If there is seaweed on the bottom, for instance, the sea may take on a greenish or reddish tone. Where the bottom is sandy, on the other hand, the water is bluish and clear.

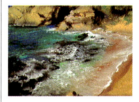

Ballestar. From the surface, the bottom of a cove appears green, some of it very dark (the Mediterranean).

Ballestar. Sand and a sea (the Caribbean) present several very distinct colors, some of which are light blue and clear.

The horizon line is the same line that separates the sea from the sky. The cubes, drawn in parallel or angular perspective, convey what the spectator would see with respect to the horizon line.

Two images of the marina of Barcelona. Note the reflections on the water in each one. They acquire much significance within the compositional and color structure of this seascape.

Reflections

The reflective capacity of stretches of water influences the structure of the composition to a great degree.

Well-defined reflections can become very prominent in the foreground. Reflections also run toward the vanishing point as do the objects themselves. But the reflected image is a distortion of the original, and the reflection's vanishing lines appear more slanted.

For instance, the height of the reflection of a mast perpendicular to the sea is the same as that of the mast itself. But in a swell, a slanted mast may have a longer or shorter reflection. The reflection of boats is a common feature in many seascapes.

MORE INFORMATION

· The Landscape **p. 66**
· The Urban Landscape **p. 68**

One very significant reflection, which must be painted with all its chromatic repercussions, is that of the sun, moon, or anything that casts light on the water. In order to convey the atmosphere of a seascape containing a large proportion of sea, the painter must know how to adjust the tones of the predominating color within the reflection.

A reflection over all the water provides an atmospheric light. Note the backlighting and the dark reflections in the foreground.

A boat and its reflection in calm seas.

The elements and their reflections run toward the same vanishing point.

Boats as the Subject of a Painting: The Foreground

Boats situated in the very foreground look splendidly executed, thanks to the luminous colors and neatness of the drawing. This work is a fine example of a high horizon.

All of the elements in the foreground lend depth to the subject. The evident proportionality of the boat's lines, which gradually appear to come together as they recede toward the sea, produces the effect of depth in this marvelous seascape. The transparent atmosphere allows the clean and precisely drawn contours to be made out as far as the horizon line itself.

Olmedo. Boats.

Unique Seascapes

The sand is the subject of this "seascape." The work depicts a Mediterranean beach scene. There are the typical objects one would expect to find: cabanas, deck chairs, parasols, towels, and so on. The sea itself is absent from the painting because the painter's aim was to harmonize his work with the sand.

In the lower seascape, a container ship occupies almost the entire composition, turning the work into an almost abstract, colorist exercise.

Olmedo. A large container ship.

*Olmedo.
Sand as the main subject.*

THE FIGURE IN PASTEL

Whether painted or drawn, a figure is a representation of a human body or that of an animal. The figure has always been a very common subject in the pastel medium. Varied approaches have been used: portraits, nudes, dressed figures; and these have been presented either as the main subject or as a complement to a broader subject. The quality of chiaroscuro achieved with pastel makes it an ideal medium for capturing everything from flesh colors to all manner of textures, including animal fur, garments, and drapery.

The Figure in Pastel: A Profusion of Possibilities

The portrait is a partial representation of the figure that focuses on facial features. The nude is a sub-genre of figure painting that captures the unclothed human body. In other figure paintings, the subjects are dressed. Chapters concerning both the nude and the dressed figure are included in this book.

Because the figure genre includes animals, which are often painted in pastel, there is also a chapter dealing with cats, dogs, horses, and so on.

Anton Raphael Mengs (1729–1799). Self-portrait.

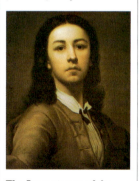

The Importance of the Sketch and the Fast Drawing

More than in any other genre, the figure should always be captured from nature in sketches and fast drawings. The artist must draw the general shape of the subject in as few lines as possible using only one color. The aim is to describe the form and movement. A correctly executed sketch is the foundation of all figure paintings.

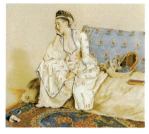

Liotard. Dressed Figure. Presumed portrait of the princess of Coventry.

Rapid sketches drawn in very few minutes. Raset has changed position with respect to the model in order to capture her from various angles.

Pose and Composition

In the chapter concerned with the still life, we demonstrated how to distribute the colors harmoniously and how to look for compositional structures. This must also be done in a figure painting. The one difference in this genre is that the painter must also search for the most interesting pose—one that is in accord to what she or he wants to achieve. With *closed* or *open positions*, angular perspectives or frontal views, whether painted wholly or partially, the figures must be placed within a neutral or natural context.

Closed positions are those that can be blocked in a single

shape—an oval, rectangle, or triangle, for instance. These are regular geometric shapes in which the direction of the arms and legs converge. As a rule they are poses of figures at rest, seated, or curled up.

Open poses are dynamic. To capture an open pose requires extending the arms and legs. These poses cannot be blocked in a single shape. Because the limbs protrude in various directions, they push through the boundaries of any geometric form.

When drawing or painting a person in movement, the artist must use an open pose to "freeze" the movement.

Atmosphere: Light and Color

The light in a figure painting determines the chiaroscuro. Depending on the quality of the light, the atmosphere may produce a sharp or blurred view of the subject.

Regardless of whether the setting is an interior or exterior,

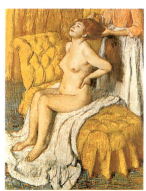

Degas. Femme nue se faisant coiffure.

the color of the atmosphere is reflected on both the nude figure and the dressed figure. The predominant color of the environment is immediately noticeable. Therefore, the choice of pastel colors depends on the actual tonal quality of the model and the interpretation the artist wishes to give it.

Flesh Colors

Due to the light and color of an environment, there is no such thing as a single flesh color. There are, however, conventional ranges of classical flesh tones that are appropriate for portrait and figure painting. Nonetheless, the intensity of contrasts and the use of complementary colors may require the artist to widen the selection of colors.

1) Moderate lateral lighting.
2) Elevated lateral lighting.
3) Intense lateral lighting.
4) Backlighting.

The Articulated Manikin

A manikin (or *lay figure*) allows the artist to reproduce practically all the movements of the human body. Because the shape of each one of its parts is stylized, a manikin is particularly useful for drawing the human figure with basic geometric shapes (see page 42).

The manikin can be used to practice linear and descriptive strokes. It is also an invaluable aid for learning about the body's proportions and articulations. But it is merely the first step. Only by studying models from nature can the artist truly develop the mastery needed to capture the body in movement.

The articulated manikin.

Sketching with the aid of a manikin.

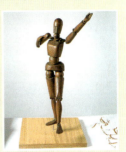

Movement and Gesture

Capturing the movement and gestures of a figure gives a painting credibility. The figure has a canon of proportions. It also has its own specific features, which must also be understood. The artist has to know about and locate the different muscles of the body he or she is drawing. Drawing or sketching rapidly, without worrying about making mistakes, is the best way to study the elements that go into a pose. The novice should begin by sketching static figures and then gradually move on to more dynamic poses.

Soft lighting with shadows.

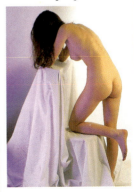

1

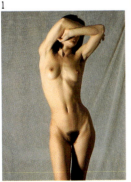

2

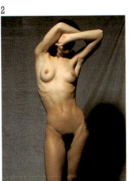

3

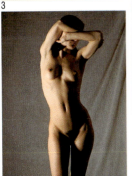

4

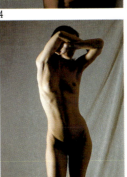

MORE INFORMATION
· The Portrait **p. 74**
· The Nude **p. 76**
· The Dressed Figure **p. 78**

THE PORTRAIT

The aim of the portrait is to define a person. One important aspect of portrait painting is to obtain a *likeness* of the subject being painted with his or her most distinctive physical features. Another important aspect is the subject's *character*. For this, the artist may seek to capture an individual's expression, in order to convey the subject's psychological and spiritual features.

Pose and Composition

The portrait can be regarded from three points of view. There is the *historical* portrait—a bust or complete body, either static or in movement, with a neutral background consisting of drapery, an interior, or a landscape. The aim of this type of portrait is to achieve a resemblance. The *sociological* portrait is primarily concerned with capturing the essence of a time or epoch. The *aesthetic* portrait is one in which artists use imagination to modify features.

The artist can choose any pose or composition. It can include only the bust (the part from the waist up), or the whole body; and it can be seated, standing, or in

The guidelines for drawing a head.

The canon of the human head, man, woman, child. The existence of a vertical dividing line.

Canon in angular perspective. The drawing of the guidelines of the canon in angular perspective. A and B are the measurements of the width of each eye. B<A. This rule can be applied to obtain the other facial features.

B

A

motion. The position of the head, whether erect or tilted, must be conveyed appropriately; and the expressiveness of the hands must also be considered.

Drawing, Expression, and Colors

The artist must concentrate on capturing the essence of the subject's facial expression and possible movement of the body. A realistic portrait demands an exact drawing that should capture all the important features. A face seen from in front, in profile, or half-tilted presents a number of difficulties. The portrait demands great powers of observation in order to capture the features correctly, as well as a thorough knowledge of color in order to obtain plausible flesh colors.

The Canon for Studying the Head

The quadrangular drawing of a head seen in profile or from the front is extremely useful for studying an individual's specific characteristics. The artist can easily recognize the anatomical variants.

The canon differs for men, women, and children. It is best to work out the most appropriate canon for each model.

The guidelines are obtained by comparing the various proportions of a specific face. The most important distances are: the space between the eyes (which is generally the same size as one eye), the forehead (from the place where the hair

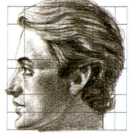

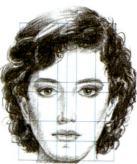

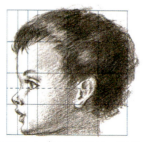

MORE INFORMATION
- The Figure in Pastel **p. 72**
- The Dressed Figure **p. 78**

commences down to the eyebrows), from the eyebrows down to the bottom of the nose, from below the lower lip to the chin, from below the nose to below the chin.

Perspective in the Portrait: Foreshortening

The foreshortening of the head allows the features to be drawn with their correct proportions according to the posture of the model.

There is also a vertical line that divides the face in two. It is very useful when the subject requires some foreshortening.

The entire face should be rendered with the correct proportions according to the degree of foreshortening required. The eyes, the nose, the mouth, and the ears are not all seen in the same way when they are observed from in front, in profile, or in a three-quarters position. The nearest elements appear bigger and the more distant ones smaller. In the case of a tilted head, the eyes must not be drawn the same size.

Volume and Chiaroscuro for Each Expression

Behind every expression there is a series of muscles at work. The study of the face's anatomy

The muscles of the human head. They perform various functions: chewing, application of the senses, respiration, expression, and so on.

Superciliaris
Frontalis
Orbicularis of the eyes
Masseter
Orbicular of the lips

reveals the bone structure and the muscles that cover it. Anatomy is the basis of facial expression. The most important muscles are the Masseter, the Frontalis, the Orbicularis (of the eyes and the lips), the Superciliaris, the Buccinator, the Risorius, and the Triangularis of the lips.

The drawing of a face must coincide with the anatomical characteristics of the subject. The pose must be foreshortened if required.

The chiaroscuro with which the drawing should be "dressed" will provide the features with their necessary volume. The flesh colors obtained with pastels have a marvelous quality. The wide ranges of colors (there are up to 100 for figure painting), and the characteristic subtle blending of this medium clearly demonstrate why so many artists use it to paint portraits.

The Hair

Hair is as important as all the other facial features. By means of artistic strokes and rhythm the painter can achieve the right color and texture for the subject's hair.

Ballestar.
The hair and its characteristics.

THE NUDE

The nude is one of the most appropriate subjects both for rapid sketching and for executing definitive works. The various parts of a nude body are not worked in the same way as the features of the face. The artist must concentrate on the model's pose in addition to the surrounding environment.

Movement and Gesture

In order to paint a realistic nude the artist should work from life. The artist's choice of pose determines the composition of this subject

For a quick sketch, the model may assume the required position for only a few minutes. For a more developed work, the session may continue for hours—with breaks from time to time, of course.

A fast drawing should always be used to capture the more difficult and tiring poses. The aim of the quick sketch is to capture the subject's tonal makeup as well as the foreshortening.

When a figure is presented sleeping, reading, or seated in a contemplative posture, we refer to it as a minimum action. Such poses can be maintained for a considerable amount of time. Therefore it is possible to complete finished drawings of these static poses while working directly from the model.

When painting a figure in a pose that indicates movement— such as jumping, walking, dancing —the normal procedure is to begin with many fast drawings.

Anatomy and Human Proportions in Practice

The main requirement for drawing a human figure is a sound knowledge of the skeleton and its musculature.

Regardless of the action indicated by the pose, it is essential to capture its movement. The foreshortening is applied by calculating the sizes of the different parts of the body from nature. There is a pattern of measurements for each subject. Let's examine the two examples that appear at the right.

The photograph on the left shows an extremely forced

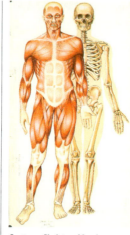

Anatomy. Skeleton. Muscles. The skin covers the muscles, which, in turn, cover the human skeleton.

position. Careful observation reveals that the size of the head is the key measurement. A curled up figure can be enclosed within a basic geometric shape—in this case, a square three times the size of the head. In the other example, which displays more complex proportions, the main reference of size is far more difficult to deduce. But once the key measurement has been ascertained, the artist will see how all the others derive from it. Study the photographs to see how the measurements of all parts of the subject relate to *A*, the key measurement.

Open Pose and Closed Pose

As we have seen, there are two main types of poses, the open pose and the closed pose. In an open pose, the model occupies more space. In the closed pose, on the other hand, the model curls up in one form or another.

The pose is one of the most important compositional elements of the figure. Whatever pose you choose, you must always maintain a balance of color masses. Open,

The sizes are taken directly from the model. By starting with measurement A, all the other important measurements can be worked out: A/2, A/3, A/4, 2/3A. The measurement of the head is the key to establishing the proportions of the foreshortening. Straight lines that cross certain important points of the contour are extremely helpful.

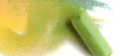

Closed pose.

Open pose.

closed, or mixed poses do not all transmit the same visual message.

Hands and Feet

Although all parts of the body convey something, the hands are one of the most important and expressive elements—second, in this regard, only to the face. Hands are complex because they have many bones and muscles. The opposable nature of the thumb along with the mobility of the other fingers pose one of the most difficult drawing challenges.

The feet, with their particular morphology, do not possess as much mobility as the hands.

First, determine the shape to block in the hand. Next, its movement and tonal gradation are drawn.

Nevertheless, it is difficult to paint a foot with the toes contracted or when the model is walking.

Frontal, Profile, or Rear View

Depending upon the pose the model assumes, certain parts of human anatomy acquire more prominence. The foreshortening keeps each area in proportion with the rest of the body.

Hands and feet in the foreground: compare their real proportions to the pictorial measurements.

Naturalness and Artificiality

To draw a figure in all its naturalness is an exercise in drawing and color. It can be achieved only with experience of painting nudes from nature.

The naturalness of a movement or a gesture is what affords credibility to the pose in a realistic painting.

Dressing the Nude: Backgrounds and Drapery

All the elements that are included in a nude painting should complement or highlight the subject. Although not in a literal sense, they help to "dress" the figure.

The inclusion of color around the figure, such as objects or a simple piece of drapery, creates a specific atmosphere that bathes the scene with its predominant color. This is because the colors of a background or drapery are reflected onto the skin of the model.

Flesh Colors and Highlights

Volume is conveyed by chiaroscuro, with the implication of the atmospheric illumination, and by the highlights.

The capacity with which the pastel medium can transmit the quality of the chiaroscuro of flesh is virtually limitless. With soft colors or potent impastos, pastel painting conveys the nude's volume with a wealth of hues. The reflections or highlights on the body from colors surrounding the figure can give rise to interpretations based on contrast, with the use of complementary colors, or in subtle harmonization.

A model drawn from the front, in profile and from the rear. Note the most significant lines and the shading. These sketches have been splendidly executed.

MORE INFORMATION

· The Figure in Pastel **p. 72**
· The Portrait **p. 74**
· The Dressed Figure **p. 78**

THE DRESSED FIGURE

The dressed figure is suitable for most everyday scenes—including both exteriors and interiors. It is important to discern the model's anatomy and master the fall of the drapery.

The Dressed Figure: Detail or General Outline

The treatment of the clothes is important when the figure is the center of interest in a picture. Sometimes this will entail a great deal of meticulous work. But when dressed figures are merely a complement within a more general subject, both the figure and its clothes should be reduced to essentials. Nevertheless, the colors and outlines of even the most diminutive figure must convey a credible movement.

The figures in this painting, *On the Beach* by Eugène Boudin, form part of the subject. They

appear small in proportion to the work as a whole. Their size alone compels the artist to bring out only the most essential elements.

This is a difficult task, indeed, even though it all comes down to a few lines and patches of color.

The Human Body Dressed: Different Fabrics and Textures

Tight-fitting garments perfectly outline the human body. Looser garments partially conceal the shape of the body, but they continue to outline it wherever they adapt most closely to its form.

Garments have folds and creases. Furthermore, each fabric has its own particular fall. A cotton sheet, a bath towel, a silk garment—from a pictorial point of view, each has its own unique texture and reflection.

With the type of chiaroscuro that can be obtained with pastels, a fold or a crease revealed in direct or diffuse lighting can be

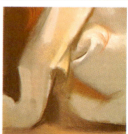

Note the highlights, large folds, and numerous creases of this dress. Detail.

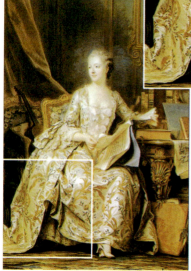

Maurice Quentin de Latour. Portrait of the Marquess of Pompadour. Note the meticulous detail that has gone into painting the dress.

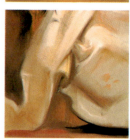

Ballestar. The sketch is drawn with an earth-colored stick of pastel on a dark ochre sheet of paper. The zones of light, half-tone, and shadow are outlined. Finally, the highlights, the brightest parts of the folds, are added.

reproduced with photographic accuracy.

The shape of the model's dress must be deduced by the pose and vice versa.

Creases and Folds

The garment that envelops a figure produces folds and creases due to the volume of the body and the tension the fabric undergoes when the model moves.

Certain zones of the body, especially those where the joints are located, produce the most significant creases and folds. A folded arm produces creases both inside and outside the sleeve. There are also creases under the armpits. When a figure is seated, creases appear in the groin area and at the knees.

Whether the garment is baggy or tight-fitting, the folds and creases depend on the position of the figure and the stiffness or flexibility of the fabric.

Thus the fall of the material over the human body delineates its anatomy.

Painting a Fabric

Observe these illustrations. When painting fabric, as with any other subject, the most important folds and creases should be delineated. A piece of fabric draped over an object or figure outlines the form it covers.

The lightest zones are drawn with darker lines. The volumes are gradually brought out as more colors and tones are added, regardless of whether they are light or dark.

Where the folds reveal a bulge under the fabric, illumination will cause a highlight. From this bright area, a full gradation will occur into the darkest zones.

The folds and creases depend on the nature of the fabric. The texture captured in pastel must allow the spectator to recognize the type of fabric by means of lines and color.

The main challenge here is to reproduce the stiffness or softness of the garment (with respect to its fall) and all the tonal gradations (with respect to the color). Rigid folds and creases require more

Ballestar. A special case. The fall of wet fabric on a human body. The water makes the fabric heavier, as well as making it cling more closely to the body.

color contrasts, while softer ones require more gradations and blends.

The pose produces tensions in the garment. There are visible creases around the model's bent knees. The position of the arms produces many creases in the T-shirt.

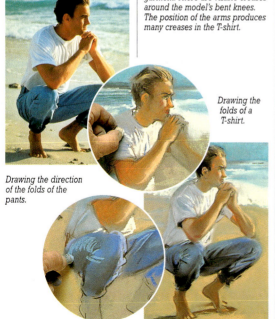

Drawing the folds of a T-shirt.

Drawing the direction of the folds of the pants.

The Reflections Produced on Flesh: The Color of the Environment

All atmospheric colors are reflected to a greater or lesser degree on all surfaces. The model's type of skin—light or dark, effulgent or matte, smooth or wrinkled—determines the number and quality of the highlights, reflections, and the tonal variations.

Shiny, brocaded, or silky garments produce more reflections. Silk may be translucent.

MORE INFORMATION
· The Figure in Pastel **p. 72**
· The Portrait **p. 74**
· The Nude **p. 76**

ANIMALS

Animals are also apt subjects for painting in pastel. Some of the earliest-known paintings include an animal as a complementary element of a portrait. With the advent of Impressionism, the horse was introduced as a subject—particularly in works dealing with the race track. Today, interest in painting animals has increased considerably. Zoos, movies, and television have made the exotic world of forest and jungle animals a familiar aspect of everyday life.

Painting an Animal: Difficulties

To capture an animal in motion is extremely difficult. It is a challenging mental exercise to obtain an image of the creature's characteristics and summarize them in a sketch after having observed the movement.

Knowledge of comparative anatomy can prove invaluable and allow you to understand what you are seeing.

Capturing the Essence of Movement: Sketching and Blocking In

Anything can be blocked into a simple geometric form. Therefore, it helps to observe a specific posture of the animal in question. By careful analysis, it can then be blocked into a simple shape.

The head is often used to gauge the other proportions of the body. With this key measurement, the artist draws a simple sketch with the main lines describing the movement. The sketch is then transferred onto the support with faint lines, establishing the structure over which color is later applied.

To summarize: once you have established the exterior form of

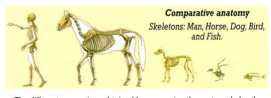

Comparative anatomy
Skeletons: Man, Horse, Dog, Bird, and Fish.

The different proportions obtained by comparing the anatomy helps the artist to avoid making significant errors, such as an excessively large pigeon.

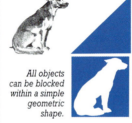

All objects can be blocked within a simple geometric shape.

the animal by using the blocking-in technique and adjusting the proportions, the main lines are added with color. Your task now is to bring out the volume by blending and highlighting the most important parts.

The last phase consists in adding the last touches that help identify the animal—posture, movement, and even its expression if you can.

Let's examine a sketch by Ballestar. With sparse color and few lines he has captured the essence of the bear.

Different Textures for Different Animals

Birds have feathers, snakes have scales, mammals have skin, hair, or fur. Of course, different textures require different pictorial treatment. Study the illustration of these three types of textures. First, note how color strokes, blending, and highlights are used to develop the plumage of the owl. In the second series, you can see how the skin of these dolphins has been treated. The pictures of the chimpanzee reveal the light skin of its face, contrasted with the dark hair that covers the rest of its body.

MORE INFORMATION

- Sketching **p. 52**
- First Colors **p. 54**
- Enhancing **p. 56**
- Blurring and Erasing **p. 58**
- The Final Touches **p. 60**

Gallery of Animals

Bear in mind that the artists who painted these animals all started by drawing fast sketches in order to capture the essence of the movement with the fewest possible lines. In general, they were executed with media directly linked to pastels, such as Conté crayons or sepia sticks. In the definitive paintings, the artists concentrated on defining the texture—feathers, skin, or fur—of the animals.

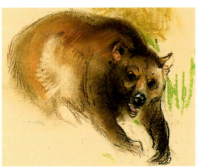

With sparse color and very few lines, Ballestar depicts the bear. He defines its bulk, movement, fur colors, and the roundness of its paws.

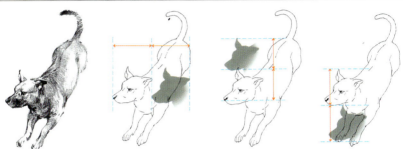

You must take the head as a measurement for calculating the proportions of a dog.

Different textures for different animals

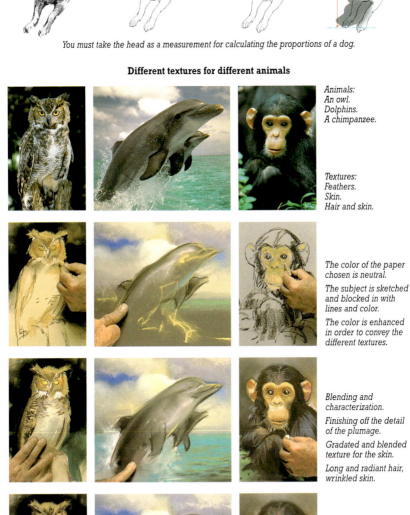

Animals:
An owl.
Dolphins.
A chimpanzee.

Textures:
Feathers.
Skin.
Hair and skin.

The color of the paper chosen is neutral.

The subject is sketched and blocked in with lines and color.

The color is enhanced in order to convey the different textures.

Blending and characterization.

Finishing off the detail of the plumage.

Gradated and blended texture for the skin.

Long and radiant hair, wrinkled skin.

Highlights, reflections, final touching up:

Highlights in the pupils.

Highlights on the skin surface and a few hairs.

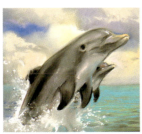

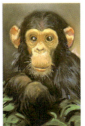

EFFECTS WITH WATER

Because pastel is a dry medium, it can be combined readily with water. This should not come as a surprise. Like pastels, watercolors are pigments with gum arabic (or another similar chemical product) as a binder. The main differences between pastels and watercolors are the proportions of these ingredients in their composition. In addition to pigment and gum arabic, pastels contain chalk and preservative. The watercolor artist mixes color with water and applies the combination with a brush. Pastels can also be mixed with water, but the effects are slightly muddier than those obtained with watercolors.

This subject provides an attractive exercise, thanks to its colors and rhythm.

The background is darkened by painting it in a dark earth color.

Pastel Paper or Watercolor Paper

We have already mentioned the best types of paper for applying pastels as a dry medium (see pages 22–25). When applying wet pastel, the artist must choose a different support.

To succeed with the mixture of water and pastels, the painter requires paper that can absorb the moisture without being destroyed by it.

Canson's Mi-Teintes paper, which absorbs very little water, is

Pastel Applied with Water

Pastel is a dry medium. However, its composition allows it to be combined with water. Consequently, the artist can employ the pastel both as a dry and a wet medium interchangeably.

It is useful to know that the effects of pastel and water are slightly different from those obtained with watercolor. This is especially true with light colored

1. Load a small amount of water onto the brush.

pastels, in which the proportion of chalk is greater. By combining these colors with water we obtain more opaque, muddy effects.

The best way to get to know the colors produced by mixing pastels with water is to make tests on a separate piece of paper. The artist must learn how to calibrate the intensity of the water-based colors and become familiar with the effects of transparency on paper. A pastel color applied dry produces one color. When wet, the chromatic quality changes.

3. The pastel colors are applied to two fans. Here blue is being applied.

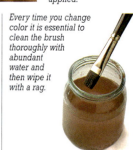

Every time you change color it is essential to clean the brush thoroughly with abundant water and then wipe it with a rag.

2. Dampen the color with the brush and spread it over the paper. The stroke looks more like watercolor than pastel.

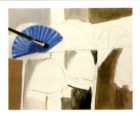

The blue fan. Two blues are used.

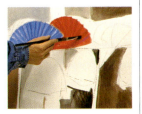

The red fan. A single tone.

inappropriate for this purpose. Watercolor paper with a suitable thickness is the best possible support for painting pastel in wet or mixed form.

Fasten the support to a board using masking or drafting tape. This will prevent the paper from curling when it is wet.

Pastel as a Wet Medium

The colors are applied on the paper in stick-form. Then the brush is dipped into the water and the pastel application is dampened. Note how the paint is diluted and how the brush extends the color.

It is also possible to mix the pastel color and water together in a separate container and apply it as watercolor.

The use of a brush allows the artist to apply the wet pastel and to obtain interesting brushwork.

The artist can apply both dry and wet pastels in a single work. The artistic strokes (dry) combined with the brushwork (wet) help to enhance the results.

Take care. Don't forget to wash the brush thoroughly before you change color. Failure to do so will dirty the next color you want to apply.

MORE INFORMATION
· Combined Techniques 1 **p. 88**
· Combined Techniques 2 **p. 90**

Painting Pastel with Water

In this exercise, we have applied wet pastel on a thick piece of watercolor paper. As always, the first step is making a simple sketch of the elements. Marking in the darker spaces, the artist works by alternating the layers of dry pastel color on watercolor paper. Then the wet pastel is applied, cleaning the brush every time the painter changes color.

Each time the painter wishes to paint over a wet zone with a stick of pastel, he or she must wait for the area to dry.

The wet colors can be alternated with other wet colors.

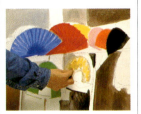

A mixture of colors applied with water.

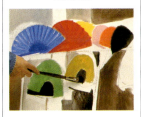

Pastel with Water: Limitations and Advantages

One limitation of wet pastels is the capacity of the paper to absorb water. Another is the muddiness of the mixes obtained.

Water can ruin the quality of blends. Many painters use pastel with water primarily to create backgrounds. In other cases, a mixture may provide a specific effect in a limited area. Mixtures can also be used to obtain an element of contrast.

The most significant advantage

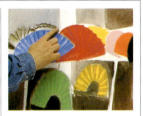

Alternating the dry medium (blending).

Pastel applied with water (a touch of water extends the color).

Pastels Can Be Mixed with Any Water-Based Medium

Since pastels can be used with water, it immediately becomes obvious that they can be combined with any water-based medium. This book includes chapters that deal with interesting mixed media that can be combined with pastel.

Altering a color by applying another color on top of it. The second color was mixed with water separately.

is the way in which the wetting of pastels increases their capacity to adhere.

Pastels and water can provide highly interesting pictorial effects, if the artist knows how to exploit the technique appropriately.

CRAYONS

Due to the characteristics of their components, crayons can be applied "cold" (the conventional manner that is widely used by school children). It is also possible to apply them "warm" (using the *encaustic* technique developed by the ancient Greeks). Furthermore, the elements that are included in the pigment of crayons can be dissolved in cold turpentine. Crayons, probably one of the most spectacular and surprising of the media, are rarely used today since encaustic painting is no longer popular.

Crayon Colors: Composition and Techniques

Despite the fact that crayons look like pastels, the former have several special characteristics.

Although crayons also come in sticks, these sticks end in a point. Depending on the brand, they vary in size and thickness. They are sold in a short pencil-like form. They are also available in the same size as a conventional soft pastel, although somewhat thicker and always with a point.

Crayons are made of a substance of either animal (beeswax), vegetable (Japan wax), or mineral (paraffin) origin, which is used to bind the pigment together.

Modern-day crayons are

Applying color directly ("cold") with a crayon.

made of liquid-based pigments (a casein alkaline solution) and an oil base (resin dissolved in linseed oil).

This is why crayons can be worked in various ways, all of which can be alternated in a single picture. They can be used cold, in other words, painting directly with the stick. Turpentine can also be used to dilute the cold colors. This liquefies the wax, lending a semi-damp appearance to the color. The third option is the warm procedure, that is, by heating up the crayon to make the wax melt. Crayons do not take long to recoup their consistency; all the painter need do is allow them to cool down.

Lines of white crayon mask part of the area painted with a thinned-down color.

Given its composition, wax is waterproof. Consequently, it can be used to reserve areas when working with any water-based medium. For more information concerning reserves, consult the section "Wax as a Reserve" on page 85.

What Do Pastels and Crayons Have in Common?

Pastels and crayons are both dry media. As such, they can both be considered drawing media.

Both contain abundant pigment, which allows them to be applied as thick layers of color on paper.

Crayons can do everything that pastels do, although the results are quite different.

The main component of crayons is wax. This component allows them to be used in a wide variety

of ways. To summarize, wax crayons can be painted dry (with the same procedures used to apply pastel); they can be used in conjunction with turpentine; and their tips can be heated until the wax softens and begins to melt.

Crayons Applied "Cold"

Crayons applied "cold" merely refers to the fact that they can be used in the same way as any other dry medium. Drawing and painting with cold wax produces spectacular results. The color patches in crayon are luminous and translucent. If the effect with pastels is dusty, the result with crayons is clean, if a bit grainy.

Crayon and pastel behave differently when blended. With crayons, blending is carried out by dragging a stick that has been softened by the warmth of the

One consequence of the waterproof characteristic of crayon: the possibility of painting in "negative," using wax reserves to achieve interesting plastic effects.

fingers. As with pastels, more color can be applied by blending or spreading the wax with a cotton rag or a stump than when blending with a finger.

Blends executed with crayon are more problematic. The surface of paper colored with crayons is difficult to erase. Crayons leave behind a layer of wax on the erased area, and this layer cannot be completely removed. If another color is applied over the area, it "slides off." When this occurs, it is necessary to use a fixative. Consequently, the artist must have a good idea of the mixes she or he is going to carry out. Blending over the appropriate colors is the best technique.

Wax as a Reserve

Because a layer of wax impedes another application over it, crayons can be used to create a *reserve*. The word refers to the way in which a layer of wax can be used to seal off an unpainted or a previously painted area when a color is applied over it. This is possible because wax is waterproof.

Crayons and Turpentine

Although crayon colors can be dissolved in turpentine, the basic nature of wax continues to characterize the painting from both a technical and an aesthetic point of view.

However, a painting done in wax diluted with turpentine has a number of advantages. Its adherence to the support is improved, and because it is completely water-resistant, wax protects the work from dampness. But above all else, it is the quality of the color produced with turpentine, which acquires sharp and satiny tints that is most desired.

Wax can be dissolved in turpentine. On the left, lines applied with crayons. On the right, the result of an application of turpentine with a brush.

This still life has been painted with crayons. By applying a thinned-down black solution, only the tiny unreserved zones become stained in black.

Melted Wax

Thick impastos and special textures are two possible applications of melted wax crayons. The artist need merely hold the crayon close to a source of heat. The wax melts slightly and before it cools down should be applied to the paper. This allows the artist to obtain the most interesting textures. Thick impastos can be achieved by repeating this procedure several times in the same area.

The heat of a flame tends to stain the crayon. It is preferable, therefore, to use a heat source that does not stain. Examples of such heat sources include a light-bulb or an electric heater. A hair dryer is particularly suitable.

A wax crayon can be melted down using a source of heat that does not stain the color. Because the artist can control the degree of liquidity, the surface can then be textured.

Painting in "Negative"

Painting in negative requires a waterproof layer to protect the negative area. A thin solution of color applied over a work executed in crayons will dye only the unwaxed layers, thus producing a negative effect.

Sgraffito with Wax

Wax crayon can be removed with a knife to reveal a lower layer of color. This technique, called *sgraffito*, requires maximum caution to avoid damaging the paper.

Colors blended cold over an area reserved with white crayon. Two areas of sgraffito have been effected here. One is linear and the other is a rhombus-shaped patch.

OIL PASTELS

Oil pastels are a fine arts product that contains an oil base.
Although they are sold as sticks, oil pastels do not behave
in the same way as conventional pastels.

Oil Pastels

Oil pastels are sticks made of pigment and an oil-based binder. These pastels can be used both wet and dry. The oil in their composition improves their adhesion to the support. Oil also alters their consistency, making them more akin to crayons.

Like any other oil color, oil pastels can be dissolved with turpentine. As a dry medium, oil pastels can be used for drawing. But when combined with turpentine and linseed oil, the results take on the appearance of a painting.

The most conventional support for pastels is paper. This is not suitable for oil pastels, unless the paper is protected with a primer. The type of primed canvas used for painting with oil paints is the best support for oil pastels.

Soluble in Linseed Oil and Turpentine

The pastel's oil base allows it to be dissolved with turpentine and linseed oil (approximately 60 percent of the former to 40 percent of the latter). The technique employed for painting with this medium is similar to that of oil painting. But because oil pastels come in stick form, they can produce unique effects.

Dry pastels can be applied directly onto the canvas. A drawing in oil pastels can provide a perfect base for an oil

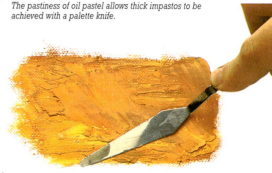

The pastiness of oil pastel allows thick impastos to be achieved with a palette knife.

painting. There is one point that should be taken into account: oil paints are applied fat over lean. Pastels and oil pastels are absolutely compatible. But the first layer of color applied must be dissolved with turpentine—in other words, applied lean.

Oil pastels can be diluted with turpentine. Note how the brush loaded with turpentine spreads the color.

To summarize, oil pastels can be worked with turpentine. If they are applied with a brush over a drawing executed with the same pastels, the color will dilute and acquire oil paint-like characteristics.

A Different Consistency

The consistency of oil pastels is different from oil paints. As you can observe, oil paint straight from the tube is creamier. The consistency of the pastel allows the artist to sketch and outline the preliminary stages of an oil painting in a dry medium. These advantages make it ideal for working outdoors. It is also cleaner to work with and lessens the load to be carried.

Thick Impastos

The consistency of oil pastels allows it to be applied in thick

Working with thick impastos.

Oil pastels have a dense consistency. They cannot be blended like conventional pastels.

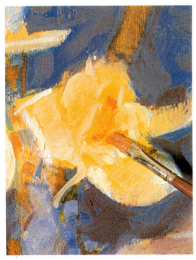

The flower was first painted with oil pastels. Oil paint has then been applied on top. Oil pastels and oil paints are totally compatible.

Sgraffito technique accomplished with a screw. Any instrument can be used to open up grooves and remove color.

MORE INFORMATION
· Crayons **p. 84**
· Combined Techniques 2 **p. 90**

impastos with a palette knife. Oil pastel impastos can be laid over a pre-painted oil base.

When oil pastels are alternated with oil paints, the different consistency allows the artist to achieve impastos of highly interesting textures.

Sgraffito

The sgraffito technique, which can be applied to conventional pastels and crayons, also works well with oil pastels. Their consistency is perfect for opening up grooves. Use any implement that works.

An urban landscape painted with oil pastels and turpentine. The final touches were added directly with the sticks.

Wax and Oil

Since crayon can be mixed with turpentine, why not use it in conjunction with other media that also possess this characteristic? Delacroix painted the Chapel of the Angels of the Church of Saint Sulpice with a combination of wax and oil.

The wax dissolved in cold turpentine can be combined with oil paint, lending a satin and matte appearance to the work.

Delacroix. The Fight Between Jacob and the Angel. *A mural in oil and wax.*

COMBINED TECHNIQUES 1

Pastel is perfect for use in combination with other media. A combined technique
is one in which at least two different pictorial media are harmonized.
Such a combination is used when the potential pictorial effects are ideal
for developing a particular subject. It is also used to offset some of the
limitations inherent to each medium when used in isolation.

Compatibilities—Incompatibilities: Dry Media

Using a combined technique presupposes a good command of the chosen media. These media may interact physically to repel each other, or may simply be used side by side on a support compatible with both.

Pastel Can Be Mixed with Many Other Pictorial Media

Pastel is compatible with all dry media, the most suitable being charcoal, Conté, and wax crayons. Used wet or dry, pastel is also compatible with watercolor (see page 90).

The Support

The paper, or other support, must offer an adequately adhesive surface for the different media the artist wants to combine.
In the case of dry media combinations, conventional or unconventional pastel supports are quite suitable.

Charcoal, Conté, and Pastel

This is one of the oldest mixed techniques. Many artists use charcoal and/or Conté for the preliminary study and sketching in the compositional lines, and then they move on to paint in pastel.
It should be noted that charcoal dirties colors. Therefore, when it has been used for the preliminary sketch, it is advisable to remove it later with a clean cloth.
Any charcoal remaining on the paper is sufficient to mark off the main forms of the sketch.
Using Conté or a sepia pencil is a cleaner method and is conducive to obtaining a warm, overall tone.

Pastel and Wax Crayons

Pastel and crayons are two dry media that can be combined for painting. They are similar media, which, when used together, can produce marvelous textures and thick color impastos. The techniques characteristic of both media can easily be combined: blending, masking, sgraffito, impasto, and so on.

Miquel Ferrón. Still life painted with Conté and white chalk highlights. The color of the paper plays an important part in producing the effect of volume. The darker areas are blocked off, defining the light areas. The entire gradation of tones available with Conté are used on the white paper.

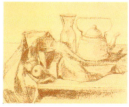
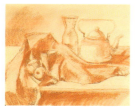
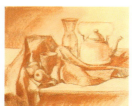

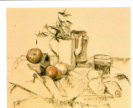

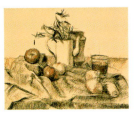
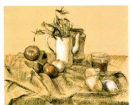
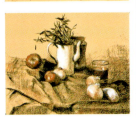

Miquel Ferrón. This still life was painted in the style of dessin à trois crayons. That is, it was painted in charcoal, sanguine, and white chalk reliefs. The color of the paper, the charcoal, and the Conté can be used to obtain full gradation of the darker colors. Touches of white are applied to the lighter, shinier points. This helps to increase the gradation of the lighter colors.

Blending with pastel is different from blending with crayons (see page 84). Using these subtle differences can greatly enrich a work.

Painting with a wax color and then painting over it with pastel can produce some truly interesting textural effects, as wax has the property of binding pastel.

Wax's capacity to reserve areas can also be used in combination with pastel. If a pastel color is applied over a surface reserved with wax, it produces a negative image. The wax covered areas cause the pastel to take on a denser texture while the pastel colors alone produce a negative image. If we then combine pastel and wax

with sgraffito, we can multiply the potential for texture and effects. An impasto can be thinned using a palette knife. In addition to this, any problems caused by the saturation of the paper can be lessened by alternating pastel and wax crayons. The enormous potential for different effects and pictorial results of this mixed technique is obvious.

Combined Techniques with Various Media

Pastels can be combined with all dry media, because they are all compatible. It is a question of knowing how to use them suitably. A combined technique should only be used in order to obtain a specific effect.

For instance, a faint layer of charcoal, adjacent to a slightly more opaque color applied with pastel or crayon, creates a striking textural contrast. The artist must not overuse this technique. Excessive use of such effects can ruin the originally desired effect.

Joan Sabater. Pastel and wax crayons.

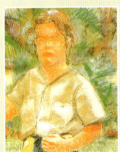
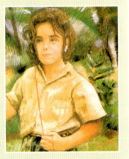

First, wax has been used and then colored over using pastel. Note the result.

MORE INFORMATION

· Oil Pastels **p. 86**
· Combined Techniques 2 **p. 90**

COMBINED TECHNIQUES 2

Pastels can also be combined with wet media. The two types of wet media
with which they can be combined are those that are water-based
and also those that are oil-based.

Mixed Techniques Using Pastels and Water-Based Media

Dry media can be mixed with water-based media. In the case of pastels, this includes watercolor, gouache, acrylic, ink, felt pen, and so on.

When dry and water-based media are combined, the paper must be able to absorb the moisture without warping. The best paper to use is thick watercolor paper, attached to a board with masking tape. This will prevent the work from twisting out of shape (and not recovering its original shape when dry).

Pastel and Felt Pens (Water Soluble)

Felt pens that dispense water-soluble ink can be combined with other media that have a high pigment content, such as pastel. Using a brush, a cotton swab, or a piece of sponge, the pigments (pastel and ink) are moistened with water.

Pastel and Watercolor

Pastel and watercolor both have a high pigment content. Watercolor is a highly transparent medium, and we have already seen the effects of water on pastel. Both media are highly compatible and can combine perfectly well, whether the pastel is used as dry or wet. The effects can be enhanced by leaving the dry areas hatched, in contrast with the watercolor brushstrokes.

When used together as wet media, the effect of watercolor and pastel (dampened with water) appears muddier than watercolor used alone.

Pastel and Gouache

The difference between watercolor and gouache lies in their varying opacity. Gouache colors are more dense and opaque as they contain a greater proportion of pigment, which also gives them more covering capacity.

Mixing pastel and gouache is a common technique among pastel artists who want to increase the resistance and adherence of their pastel colors, while the density of gouache allows them to alternate the media. The only precaution necessary is to let the surface of the paint dry before adding more pastel. Thick color impastos for producing highly creative, textured results are also possible.

Gouache helps reduce the flaking of pastel, although the work still deteriorates with moisture.

Crayons, Watercolor, and Gouache

hick-grain, heavy weight watercolor paper is the ideal

Wax crayons stain the upper part of the grain, leaving the lower parts white.

By applying a wet, blue watercolor over a dry, red wax crayon a negative image can be obtained.

Thick-grain watercolor paper is used as the support for this technique combining wax, watercolor, and gouache. The Briefcase, by M. Braunstein.

The painting in the final stage of coloring with crayons.

A later stage. Watercolors have been added in different colors with highly diluted washes. This effect is offset by the contrast with the pointillist-type wax colors applied on thick-grain paper to increase the plasticity of the work.

support for this technique combining wax crayon, watercolor, and gouache. Note the casual style of the still life and the enlarged color samples.

Pastel and Acrylic

At first sight, acrylic paint greatly resembles gouache. Like gouache, acrylic is a dense, water-based medium. Used without water acrylics are opaque; highly diluted, they become transparent, much like watercolor.

Acrylic's high resistance when

Sample. Pastel and acrylic.

Adding a few touches of gouache helps to highlight the profiles and increase the sensation of volume and depth. The lock, straps, and buckles now stand out.

dry is due to its synthetic chemical composition that makes it water- and shock-resistant. When acrylic is mixed with pastel, it polymerizes the blend.

Pastel Combined with an Oil-Based Medium

Pastel can also be combined with oil-based media. When dry and oil-based media are used together, the paper or canvas must have a protective primer. The typical oil stains and rings should be avoided. Pastel colors can also be mixed with oil.

Picasso: Pastel and Gouache

All great painters have employed combined techniques. Here is an example that fits nicely into this chapter. This work was painted in pastel and gouache. Note the thickness of the yellow impasto and the contrast with the black pastel.

MORE INFORMATION
• Combined Techniques 1 **p. 88**

CONSERVING A PASTEL WORK

The difficulty of properly conserving a work painted in pastel explains the controversy over using fixative and the research carried out into the use of mixed media to improve the adherence of pastel colors. The definitive way of conserving a pastel work undoubtedly lies in framing it correctly.

Aesthetics and Conservation

As a pastel work needs framing in order to conserve it, why not take the opportunity to enhance its aesthetic effect at the same time?

The definitive frame centers the work within several different inner frames. A mat board, with an opening cut to the proper size, contacts the front of the pastel work. If sealed between a sheet of acetate and a stiff backing, a temporary frame (called a *passe-partout*) is produced.

The mat forms a protective air-chamber between the pastel and the glass. If the artist does not want to use a mat, when framing an abstract work for example, an end strip must be used to maintain the air-chamber.

The frame itself and the mat board lend the final touch to the painting, and can be made to harmonize or contrast with the work.

There must exist some relation between the frame and the work.

Here the frame harmonizes with Francesc Crespo's landscape. The cream-colored mat gives a moderate contrast that softly separates the painting from the frame.

So, for example, a classically interpreted work may require an elaborate, carved frame. An abstract pastel may require a smooth-sided, functional frame. These are merely suggestions, as mixing styles can sometimes be used to highlight the contrast.

All stores specializing in framing can offer a wide range of matting materials. There are cloth-covered wooden boards, usually in neutral colors, although other combinations can be supplied on demand.

Cardboard mats come in a wide range of colors and are cut from sheets 2 to 4 mm thick, usually white or cream-colored on the reverse side. The mat is scored using a special knife. This is why mats always end in a white or cream-colored edge. Some artists use an additional edging to finish a *passe-partout*.

The effect of the frame, mat, and edging is to highlight and enhance the pastel work.

The dark grey mat provides a sharp contrast between painting and frame. Raset's warm colors are in harmony with the bold, golden frame.

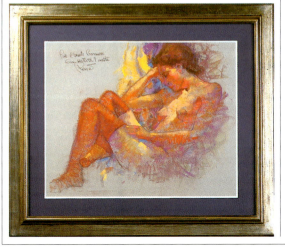

Sample of mat board colors.

The Color of the *Passe-partout*

Artists who frequently work in pastel usually have a collection of pieces of different-colored mat boards. Cut at right angles to create corners, these pieces can fit any square or rectangular format. Before cutting the mat, different colors are tried to create varied effects.

Parts of the Frame

The cross-section below clearly shows how the thickness of the mat creates an air-chamber that prevents the pastel and the glass from coming into contact. The lower panel strengthens the structure and protects the back of the pastel, which is held tightly between the mat and the support. The frame,

Sample of mat board colors.

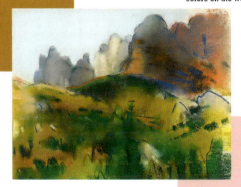

Pieces of mat board cut at right angles can be used to check the effect of their colors on the work.

Hang the Painting in a Suitable Place

A pastel painting must be hung in a place that does not receive direct light. Although the pastels manufactured today are more resistant to light, it is best to avoid damaging the work and losing the brightness of the colors. Dampness can also ruin the pastel. Bear in mind the proximity of heaters, vaporizers, open windows, and so on. Finally, remember that water is the arch enemy of the pastel painting.

which grips the backing and the glass resting on the mat, holds the entire assembly together.

There are several types of glass: ordinary transparent,

mat, anti-reflective, unbreakable plastic, and so on. Ordinary, transparent glass is the best for enjoying the true colors of the pastel.

This cross-section figure shows how an empty space is created to protect the pastel.

MORE INFORMATION

· What Is Pastel? **p. 10**

PRACTICAL HINTS

To help you get started in pastels, we have included a list of the
most essential points you should know about this medium.

• Make sure you have everything you need to paint in pastel before you begin. See page 28.

• The paper should be fastened to a board with a clip, push pins, or masking tape.

• The paper and the board should be held at an angle. If you have an easel, the board should be placed vertically.

• Always remove the paper from the sticks before you begin to paint with them.

• The sticks are extremely fragile and break easily. Always break them in half before you begin. Shorter sticks are less fragile.

• Choose the most appropriate subject and setting.

• Make preliminary sketches to structure the composition.

• Resolve all the problems of perspective in a preliminary sketch.

• Shaded sketches are very effective for studying the tones of the model.

• Study the balance of the colors. Make sure that the structure is clearly defined.

• The model can be sketched on the definitive paper with colors akin to the general color scheme. Draw the lines faintly in order to avoid unnecessary erasing.

• Only use fixative sold in aerosol cans.

• Fixative should be applied in fine, uniform layers.

• Fixative should be used to fix layers of color. A color applied over a layer of fixative will not blend with the underlying color.

• Always search for a rhythm that will make the lines and coloring best represent the model.

• Make sure you know exactly what colors you are going to require.

• Don't apply a thick layer of color without having first worked out the color structure of the painting.

• Don't blend excessively.

• Always blend in the same direction. Study the most appropriate direction and whether it should be light over dark or vice versa. Once you have chosen the direction, don't change it.

• Remember that it is not always necessary to blend. You may be better off using a colorist solution.

• If you decide to treat the work as a value painting, you can minimize blending.

• Only with experience can you calculate the amount of color required for each blended effect.

• You can conceal the texture of the paper by applying color with a finger until all the tiny pores have been filled in.

• Because pastel is an opaque medium, you can paint light colors over dark ones and vice versa. In addition, if the first colors are fixed, they will not blend with the ones applied on top.

• All types of strokes can be achieved with pastel.

• A stroke can be more opaque or more transparent depending on the pressure with which you apply the stick to the paper.

• Softly shaded areas can be cleaned with a kneaded eraser.

• Intensely colored areas cannot be erased without leaving a mark.

• Always have a clean cotton rag on hand when you are painting.

• Remember to clean your fingers every now and again.

• Remove the dust of other colors from the pastel stick before you use it. Painting with a light color that is dirty can ruin a picture.

• The compositional structure and color scheme must be planned properly before commencing. Bear this in mind when you begin obtaining contrasts and using the stump to blend.

• Always try to obtain the essence of the subject using as few strokes as possible.

• Only tone when you deem it necessary.

• Always maintain a balance between the contrasts and the color.

• Never carry out direct color blends unless it is absolutely necessary.

• Reserve the color in the areas that are destined for highlights.

• Take a break every now and again. Stand back and observe how the work is progressing. This is essential to ensure that everything is going according to plan.

• Leave the highlights for last.

• Try to avoid applying fixative over the final layer of color. If you do, you run the risk of losing the brightness of the colors. The decision to do so should only be taken after having evaluated the consequences.

• Protect the finished work by wrapping laid paper around the painting and placing it in a folder.

• Protect the finished work by framing it correctly.

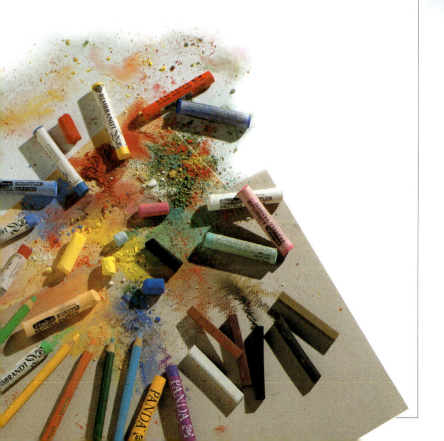

Original title of the book in Spanish: *Pastel*
© Copyright Parramón Ediciones, S.A., 1998—World Rights.
Published by Parramón Ediciones, S.A., Barcelona, Spain.
Author: Parramón's Editorial Team
Illustrations: Parramón's Editorial Team
Copyright of the English edition © 1998 by
Barron's Educational Series, Inc.

All inquiries should be addressed to:
Barron's Educational Series, Inc.
250 Wireless Boulevard
Hauppauge, New York 11788
http://www.barronseduc.com

International Standard Book No. 0-7641-5106-1
Library of Congress Catalog Card No: 98-72917

Printed in Spain
987654321

NOTE: The titles that appear at the top of the
odd-numbered pages correspond to:

The previous chapter
The current chapter
The following chapter